DRAW AND PAINT
super cute
animals

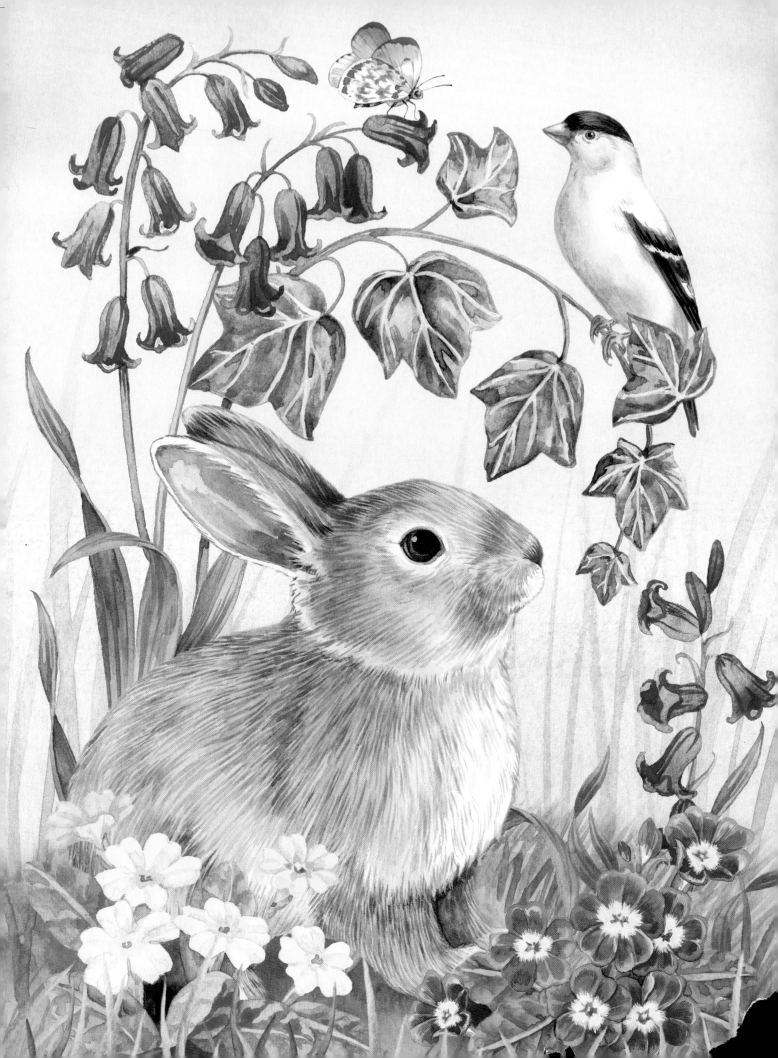

DRAW AND PAINT
super cute
animals

35
step-by-step
demonstrations
in pencil and
watercolor

JANE MADAY

NORTH
LIGHT
BOOKS

Butterflies, pg. 102

Contents

Frog, pg. 98

Goldfinch,
pg. 74

Orange Cat,
pg. 32

Bear,
pg. 88

Labrador Puppy,
pg. 38

Introduction

Cute animals appeal to everyone. Who can resist their sweet expressions, fluffy fur or brightly colored feathers? That is why they are my favorite subjects to draw and paint. My goal with my art is to put a smile on the face of everyone who views it.

In this book I'd like to introduce you to some of my favorite tools and techniques for drawing and painting adorable animals of all kinds. Remember, art is a learning process that continues throughout your whole life, and everyone has to start somewhere. I have tried to include lots of different art materials in this book, so you can experiment and find the techniques that work best for you.

I find it helpful to always have a sketchbook or camera handy. You never know when you are going to see the perfect subject. Daily sketching practice is very valuable. It is wonderful to be able to look back through your sketchbooks and see your work as your skills progress.

In these pages you will find many examples of drawing studies from my sketchbook that I use as references for larger drawings and paintings. Feel free to use these as a basis for your own personal work for learning purposes. Please note that I do retain copyright and ask that you keep them just for your own personal use.

I truly hope you enjoy using this book as much as I have enjoyed writing it. Trust that your happiness will show through your drawings and bring joy to those who see them. So relax, sharpen your pencils and have fun!

What a WONDERFUL World

Materials and Techniques

In this section I will introduce you to the art supplies you'll need—including some of my favorites— and explain how to use them. You don't need to rush out and buy everything at once. Try a few different materials at a time to see what's most comfortable for you. I do recommend getting the best quality supplies you can afford, so that you are not struggling with inferior products in addition to your own inexperience. Feel free to play, experiment and become familiar with different mediums before you try an elaborate drawing. The more comfortable you are with your supplies, the more successful your drawings will be.

Basic Supplies

One of the great things about drawing is that you can create wonderful pieces of art with few supplies and at minimal cost. Here is a selection of my favorite drawing tools. Try a variety of materials and brands to see what works best for you.

You can do most of the demos in this book on mixed-media paper. I love the mixed-media sketchbooks made by Stillman & Birn. Bristol board is also a good choice for the projects in this book.

When you are ready to begin, make sure you are in a comfortable place where there are few distractions, and have your art supplies close at hand.

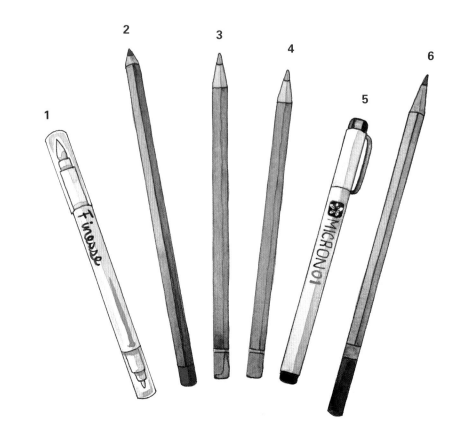

My Favorite Drawing Tools

1 **Blender pen**—A blender pen is great for blending wax-based colored pencils. Pictured here is one made by Finesse, but the Derwent brand is also good. These pens contain a colorless solvent.

2 **Pastel pencil**—Pastel pencils are great for soft effects. You can blend them with cotton swabs and tortillions. They break easily, so be careful when sharpening and try not to drop them.

3 **Colored pencil**—Colored pencils come in a variety of colors, types and brands. Pictured is a Faber-Castell Polychromos colored pencil, which can be easily blended. I also like colored pencils by Caran d'Ache and Prismacolor. Prismacolor pencils are the softest and most opaque, so they are especially good if you are prone to sore hands, or if you draw on tinted paper.

4 **Watercolor pencil**—These are water-soluble and can be smoothed or blended with water. Draw or color as you would normally, then go over the pencil with a damp brush to activate the watercolor effect.

5 **Liner pen**—Waterproof ink fine-point pens, such as Sakura Micron, are a must-have for outlining your pencil work.

6 **Drawing pencil**—Keep a selection of graphite drawing pencils from 4B to 2H. The letter indicates whether the lead is soft (B) or hard (H), and the number indicates the level of softness or hardness of the lead. You will also need a pencil sharpener. I prefer handheld sharpeners such as T-Gaal or Faber-Castell. You will get the best results by rotating the sharpener rather than turning the pencil.

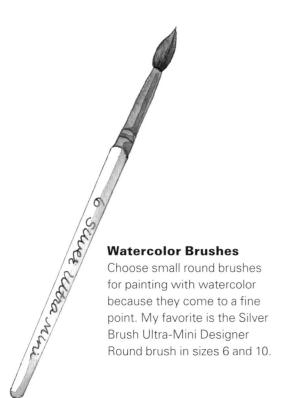

Watercolor Brushes

Choose small round brushes for painting with watercolor because they come to a fine point. My favorite is the Silver Brush Ultra-Mini Designer Round brush in sizes 6 and 10.

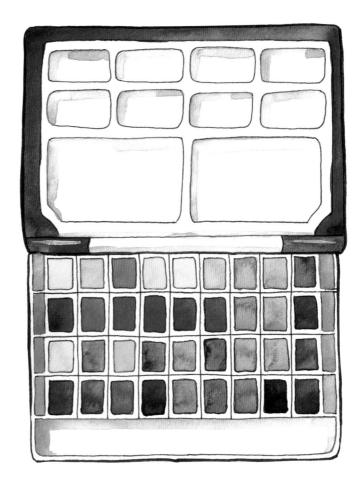

Set of Pan Watercolors

I love using watercolor pan sets because they are tidy and portable. I refill the pans from tubes when the paint level gets low. My favorite is this one from Holbein. I have customized it by adding more pans to the original set. The Winsor & Newton Cotman set is a nice, compact set at a lower price. The pans are replaceable and refillable, a great choice for beginners and those on a budget. When using pan colors, I like to spritz them with a little water to moisten them before I begin painting.

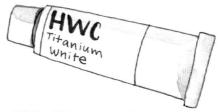

Erasers

Keep several types of erasers on hand. The kneaded eraser can be molded into a point to lift out highlights. When it's dirty, simply knead it until it's clean again. Click erasers work much like mechanical pencils. You may also want a large pink or white eraser for large areas.

Titanium White Watercolor Tube

I like to keep a tube of Titanium White watercolor on hand for adding bright, clear highlights. This can be especially effective for an animal's eyes. Make sure it is Titanium White, which is opaque, rather than Zinc White, which is more transparent.

Color Chart

A color mixing chart can be a useful reference tool for creating your palette of colors for blends of watercolor paints or watercolor pencils. You don't need to buy a lot of colors to create a large variety of hues. This is my minimum color palette of twelve watercolors. You can add or substitute your favorites, of course. For colored pencils, I like to make a basic chart just showing the colors without layering them. With colored pencils, the color indicated on the barrel of the pencil often differs from what it looks like on paper, so it is useful to have a chart for reference.

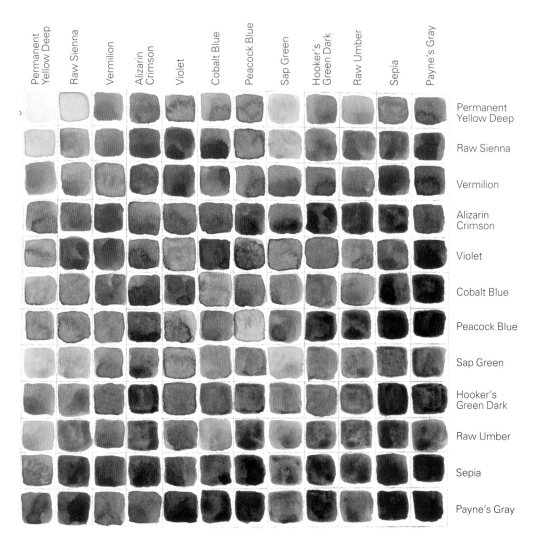

My Watercolor Palette Color Chart

Color Temperature

An important thing to keep in mind when planning your composition is color temperature. Colors can be warm, cool or neutral.

Warm Colors

Warm tones such as red, yellow and orange convey bright emotions, passionate feelings and excitement.

Cool Colors

Cool tones such as blue, green and some purples have a gentle, calming effect.

Neutral Colors

To create neutral colors, try mixing together two complementary colors such as blue and orange or purple and yellow. Using neutrals gives your paintings balance. If you used only pure, saturated colors, your eye wouldn't know where to rest. Neutrals also provide a sense of depth.

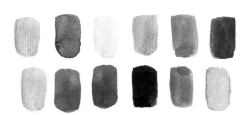

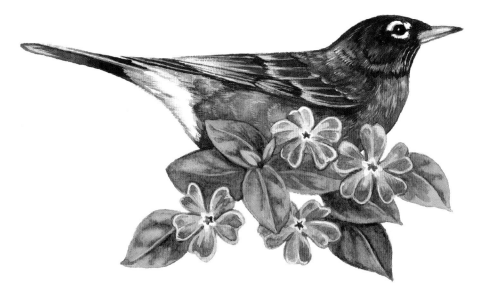

Creating Contrast

I like to contrast color temperature to help draw attention to an animal in my paintings. For example, the warm oranges and browns of the American robin help it stand out against the cooler colors of the periwinkle flowers.

Drawing Techniques

Some techniques for drawing are consistent no matter what medium you choose. In this book we will tackle a variety of methods. Take some time to experiment with your supplies so they feel familiar to you. I keep a sketchbook and I try to draw or paint in it every day. Seeing the book fill up gives me a feeling of satisfaction. I love flipping through the pages of a finished sketchbook. Practice really does make perfect, and you will see improvement from the first page to the last.

Pencil Lines
Pencils vary in softness. You can vary the weight and darkness of your lines according to the hardness of the pencil you choose, as well as its sharpness. The top line here is drawn with a sharp 4H pencil. It is light and fine. The bottom line is drawn with a blunt 4B pencil. Colored pencils vary in softness according to brand. Some, like Prismacolor Premier, are very soft, while others, like Marco Raffine, are quite hard. The Faber-Castell pencils that I use in this book fall into the middle.

Shading
When shading, keep your strokes close together or you will get a streaky appearance. When drawing fur, I sometimes shade the animal with scribble strokes like these, which makes the animal look fluffier.

Stippling, Hatching and Crosshatching
The are many types of marks you can use for shading when drawing. Some of the most common are stippling, hatching and crosshatching.

Blending with Graphite

Many people like to use blending techniques to smooth out their drawings. This shows my shaded 4B pencil (left) blended with a tortillion (right). Tortillions are made from tightly compressed paper formed into a pencil shape. You could also use a blender pen.

Blending with Colored Pencil

For colored pencils I like to use a blender pen. These pens are filled with a solvent that dissolves and smooths the pigment. Finesse blender pens are some of my favorites. Blender pencils are also available, but I find that they sometimes lift the pigment off the paper rather than blend it.

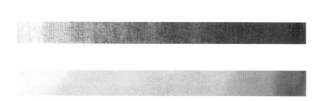

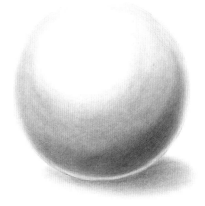

Value Strips

Value refers to the tones from light to dark. Using value helps create form so your drawings look dimensional. In pencil, you can vary the pressure to create light and dark. The harder you press, the darker the line will appear. In watercolor, you can create light tones by adding more water to the paint, and dark tones by using less diluted pigment.

Shaded Sphere

Shading is what turns a flat circle into a rounded sphere. This drawing of a ball shows how value adds form and makes the ball look round. Notice how the cast shadow underneath creates a nice depth. The highlight on the top indicates that the light is coming from the upper left. Use shading to add form, depth and roundness to your animals' faces and bodies.

Grid Method

The grid method is a good way to create a drawing from a reference photo. It's easy to get overwhelmed by trying to draw the whole thing at once, but breaking it up into small pieces helps make the job less intimidating. By concentrating on one square at a time, you can focus on each shape and line that makes up the picture as a whole.

1 Create your grid with a fine-point permanent marker on a sheet of acetate. You can also create it on your computer and print it out onto acetate. For an 8" × 10" (20cm × 25cm) photo, I would make the grid with 1" (25mm) squares.

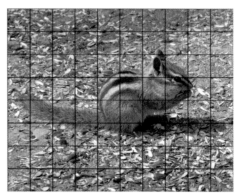

2 Lay the acetate grid over the photo. Draw a matching grid on a sheet of tracing paper. Focusing on one square at a time, copy the outline of what you see in each square. Gradually you will end up with a line drawing of your photo on the tracing paper.

You can easily change the size by making your grid proportionally larger. For example, to enlarge an 8" × 10" (20cm × 25cm) photo to a 16" × 20" (41cm × 51cm) drawing, you would enlarge the grid on your tracing paper up to 2" (51mm) squares.

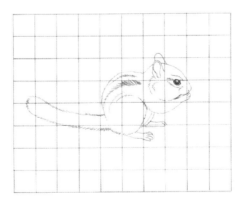

3 When your tracing paper drawing is complete, use transfer paper to transfer the line sketch to your final drawing surface. Do not transfer the gridlines.

Transferring a Sketch

I like to do my sketches on tracing paper first, then transfer the sketch with graphite transfer paper onto my final drawing surface. This way I can work out any problems with the drawing before I begin working on my good drawing paper.

Transfer paper comes in several colors, but I typically use the graphite version. White transfer paper is handy for transferring a drawing onto darker-colored papers. Red transfer paper is somewhat water-soluble, so it can be good if you are working in watercolors and don't want your transferred lines to show through.

Choose a brand that is wax-free. Saral is my favorite brand. Each sheet can be used many times until you no longer get good lines. You can buy it either in a roll or in a packet of individual sheets.

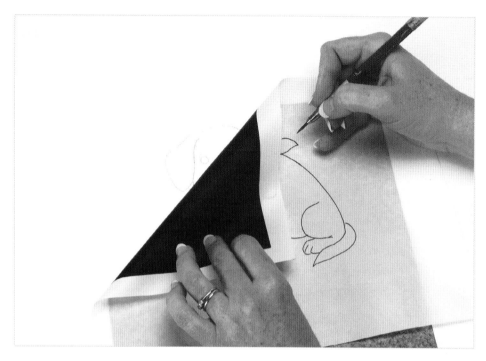

Using Transfer Paper
Attach your tracing paper sketch to your final drawing surface with drafting tape to keep it from shifting around. (Drafting tape is less sticky than masking tape, so it won't damage your paper.) Put a piece of transfer paper between the tracing paper and your drawing surface, making sure it is graphite side down.

Use a pencil with a hard, sharp lead to transfer the sketch. Do not press too hard or the transferred lines will be too dark, or you could impress the lines into the drawing surface. Lift up a corner of the transfer paper to check your progess, but be careful not to pull up the tape and move your tracing paper out of position.

DRAWING VERSUS TRACING

You may wonder why I don't suggest just tracing the photo, since you are working with tracing paper. This is simply because you won't learn anything about the art of drawing through direct tracing. If you rely on shortcuts, you risk becoming dependent on them and losing the drawing skills you already have. Once you become more experienced, you may find that you can draw what you see directly and can skip the grid method altogether.

Basic Shapes

Another way to sketch an animal is to build up your drawing from its basic shapes. This will help you learn how to draw freehand. Start sketching loosely and lightly with a 2H pencil.

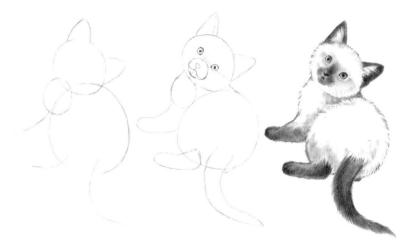

Kitten

Practice visualizing the basic shapes that make up an animal's form. Ovals and egg shapes are most common, but you will also use circles, cones, cylinders and triangles. Adding curved guidelines to the face will help you place the features.

This kitten is based on ovals and triangles. The triangles for the ears have curved lines; there are no straight lines on an animal.

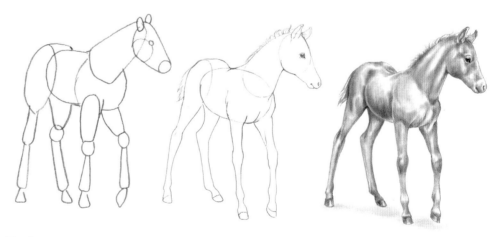

Foal

Always begin by drawing lightly so you can erase your guidelines as you develop the drawing. This foal is made up primarily of cylinders. The back legs are slightly longer, so joint placement is crucial.

Drawing and Painting Fur

An important thing to remember when drawing and painting fur is that your strokes should follow the direction of hair growth. Gradually release the pressure on your pencil or brush so that the strokes lightly taper at the ends.

Pencil Fur

When drawing fur with pencil, I like to fill in the space with soft strokes. It is better to build up the fur gradually with light pencil lines, than to draw too solidly. You may want to blend your pencil strokes with either a tortillion or a blender pen.

Erasing to Create Fur

You can also use an eraser to lift out light fur lines.

Colored-Pencil Fur

For really soft fur, try coloring your base color using pastels and then blend with a cotton swab (see sidebar below). Next, add fur strokes with colored pencils. You can also color your base color with colored pencils and blend with a blender pen if you do not wish to use pastels.

Watercolor Fur

With watercolor, I like to start with the midtones, then add the darks and finally the lights. Many people like to leave the highlights in watercolor as the plain white of the paper, but I prefer to use Titanium White watercolor. Make sure each layer is dry before you paint on top of it.

COTTON SWAB TECHNIQUE

Occasionally I like to add some soft pastel pigment to my drawings using a cotton swab like a paintbrush. It creates a softer look when adding a little warmth to the inside of an ear or to a little pink belly.

First, rub a cotton swab over the tip of a pastel pencil to pick up pigment. Then rub the pigment from the tip of the swab onto your drawing. This creates a softer smudge of color as compared to using pencil directly.

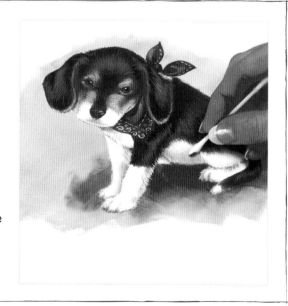

Keeping a Sketchbook

A sketchbook is a great place to work on your powers of observation as well as your artistic skills. I prefer mixed-media paper so I can use whatever materials I feel like on any particular day. My favorite is made by Stillman & Birn. I try to draw in mine every day. You can work either from photos, from life or your imagination! The key to learning how to draw well is to practice, practice, practice.

Use your sketchbook as a way to record and practice drawing animals and plants to use in future paintings. I like to use it as a place to work out colors and poses. I love having finished sketchbooks that I can use as nature guides or inspirational tools.

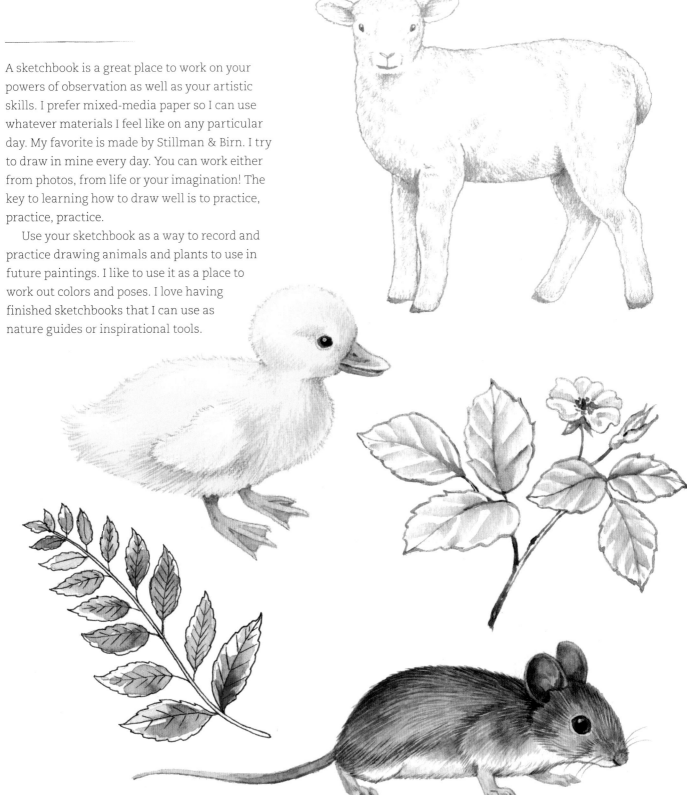

Blue Tit
Cyanistes Caeruleus

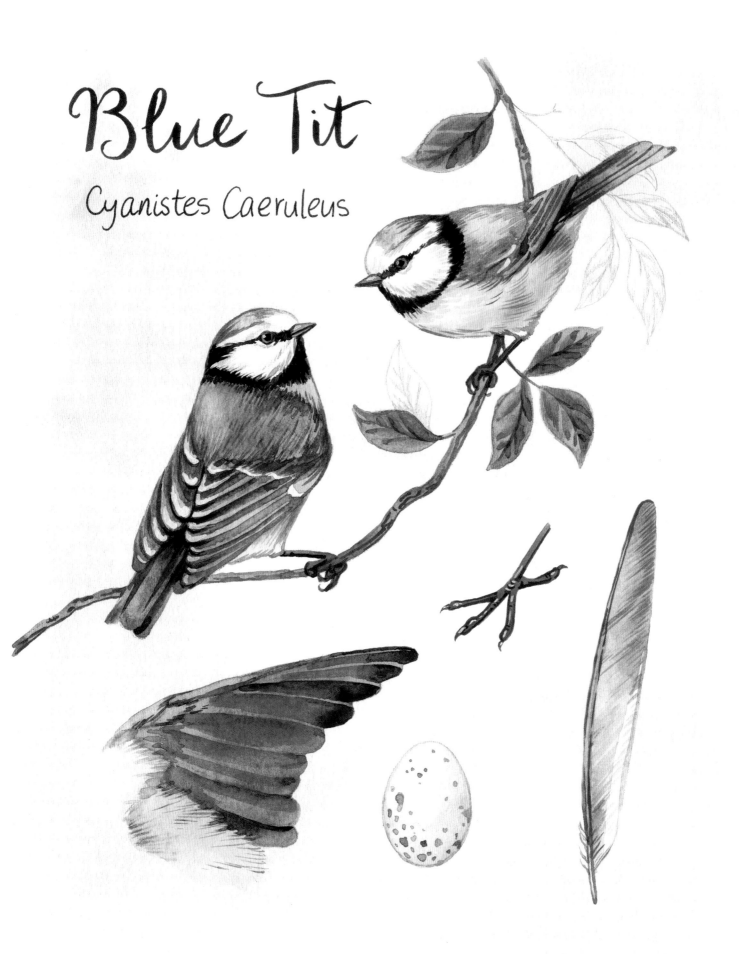

Adorable Animal Demonstrations

In this section I'll like to introduce you to my methods of drawing and painting my favorite sweet animals and birds. In most cases I have chosen animals that are common as pets and as visitors to our gardens. If you are just starting out, try to remember that art is a learning process. I still learn something new with every piece I create. Don't let your insecurities discourage you from drawing. The joy you feel in your art will show through, even if it isn't perfect!

Bunny Studies

Bunnies appear in a lot of my paintings. They are the perfect size to combine with flowers and birds to make a sweet composition.

Prey animals have their eyes set on the sides of their heads so they can watch for predators. Make sure you do not place the eyes too far forward.

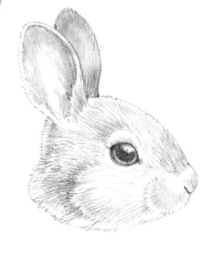

A baby rabbit isn't just a small adult rabbit. The head is larger in proportion to the body, and the ears are smaller. Baby animals appear to have large eyes because the eyes reach full growth and development before the rest of the head.

Bunny in a Teacup

Add another level of cuteness to your drawings by using scale. By placing the bunny in a teacup, we can emphasize his small size and add a touch of whimsy. For this drawing I used a fun product called water-soluble graphite. You can buy it as a pencil or as a cake that you moisten with a damp brush.

MATERIALS

bristol board, tracing paper, graphite pencils, kneaded eraser, water-soluble graphite, scrap paper, small round brush, Titanium White watercolor

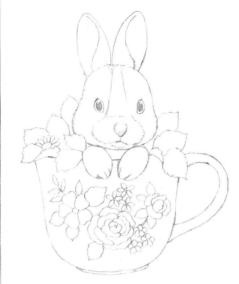

1 Sketch your bunny with a 2B pencil on tracing paper, then transfer it to a sheet of bristol board using tracing paper.

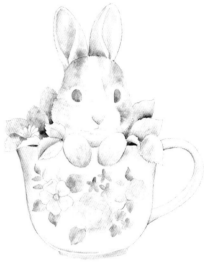

2 Fill in the base tones with water-soluble graphite and a damp brush. Add some outlining with a 2B pencil, but make sure the paper is completely dry first or you might tear it.

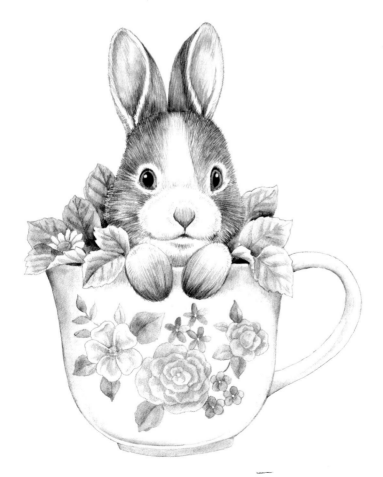

3 Fill in the fur on the bunny with 2H and 2B pencils. Keep a sheet of scrap paper under your hand to avoid smearing. Add highlights to the eyes with little dots of Titanium White watercolor.

Using the 2H pencil and delicate scribble strokes, shade the leaves and cup. Dot in the flower centers with Titanium White watercolor.

Bunny with a Flower

You can add cuteness to your animal drawings by giving them a prop to interact with. A bunny wouldn't really hold a flower like this, but it adds to the charm of his pose.

MATERIALS

bristol board, graphite pencils, kneaded eraser, pastel pencils, cotton swab, colored pencils, small round brush, Titanium White watercolor

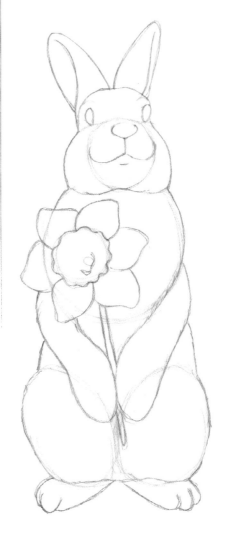 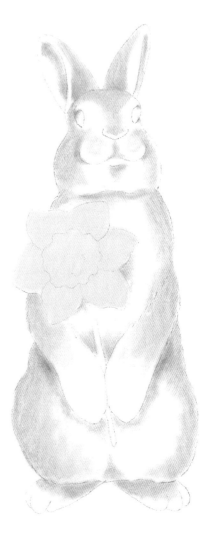

1 Begin by sketching the bunny on bristol board with an HB or softer pencil. Use a kneaded eraser to remove any unnecessary lines once you have the pose to your liking.

2 Lightly color the bunny with pastel pencils. I used Ochre, Umber and Yellow pastel pencils. Blend with a cotton swab.

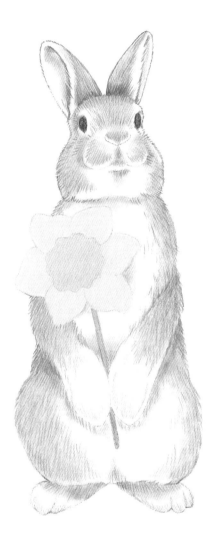

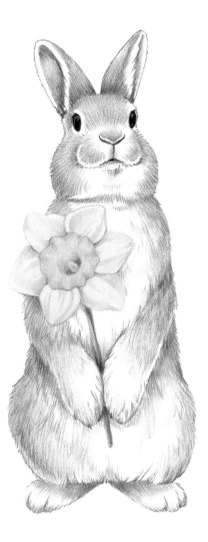

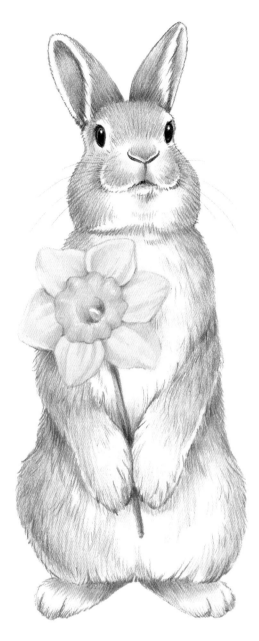

3 Add the midtones with colored pencils, using delicate strokes. Make sure to follow the direction of hair growth. I used Brown Ochre, Grass Green, Rose Pink and Fast Orange.

4 Build up the color of the fur with another layer of Brown Ochre colored pencil. Then add darker fur with Van Dyke Brown. Add pupils to the eyes with a black colored pencil. Shade the flowers with Golden Ochre, Golden Yellow and Venetian Red colored pencils. The darkest shading is Umber.

5 Add highlights to the eyes and flower with Titanium White water-color on a small brush. Emphasize the pink on the mouth and ears with a red pastel pencil, blending with a cotton swab. Draw the whiskers with a very sharp 2H graphite pencil.

Cat Studies

Cats have been popular pets for thousands of years. In that time, numerous different breeds have been created, resulting in a great deal of variation in face shape, fur length and color. When drawing fur, your strokes should always follow the length and direction of hair growth.

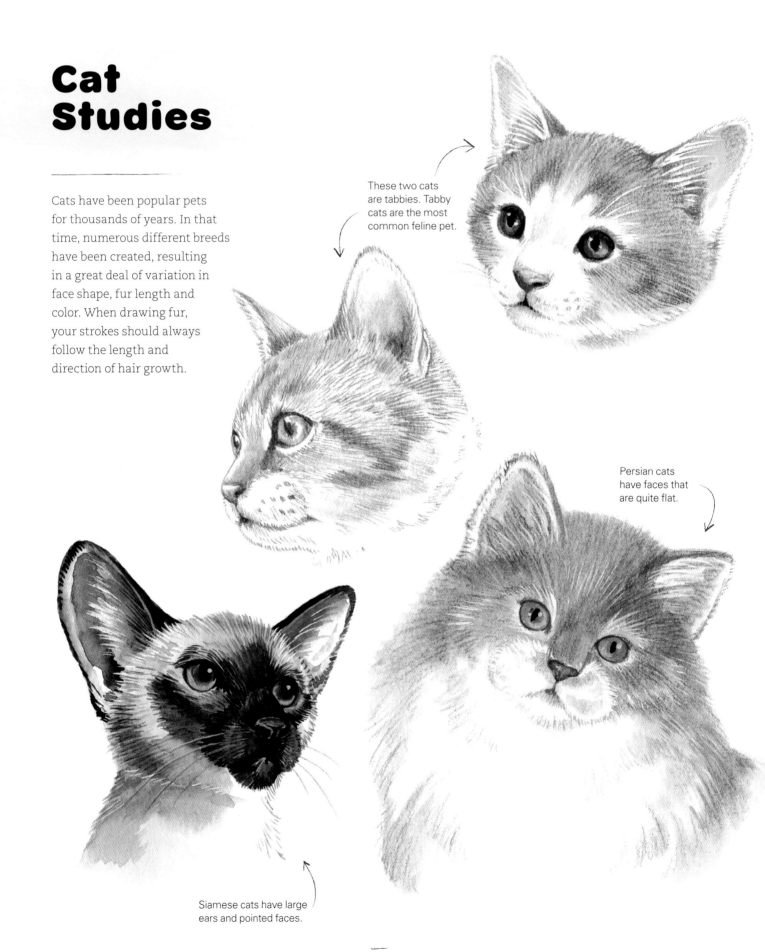

These two cats are tabbies. Tabby cats are the most common feline pet.

Persian cats have faces that are quite flat.

Siamese cats have large ears and pointed faces.

White Cat

The key to drawing white fur is to draw the shading around the white areas rather than trying to draw the white hairs individually. It is best to try to leave the white areas as plain paper. The shadows can be surprisingly colorful; try adding blues and golds rather than just plain gray.

MATERIALS

bristol board, graphite pencils, kneaded eraser, colored pencils, blender pen, small round brush, Titanium White watercolor

1 Sketch the cat's portrait with a 2H pencil onto bristol board. Lift the pencil lines gently with a kneaded eraser so they are not too dark.

2 Coloring a vignette around the cat helps the white fur stand out. I used Earth Green and Sky Blue. The nose and inside the ears are Dark Flesh. Leave the hairs in the ears as plain paper. The shading on the fur is Warm Grey II and Yellow Ochre. The eyes are Sky Blue and Light Phthalo Blue.

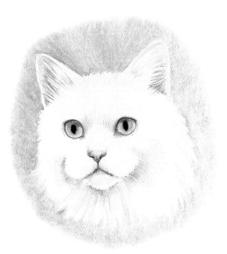

3 Add pupils to the eyes with black. Begin adding darker shading with Walnut Brown. Deepen the colors of the nose, mouth and around the eyes with Dark Flesh and Raw Umber.

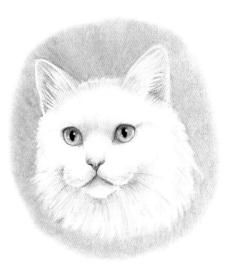

4 Continue shading with Raw Umber. Go over the background with a layer of May Green. Blend everything with a blender pen. Add highlights to the eye with Titanium White watercolor, and whiskers with a 2H pencil.

Surprised Kitten

Another way to add cuteness is through expression. This kitten has a somewhat surprised look, and that gives him personality.

MATERIALS

hot-pressed watercolor paper, tracing paper, graphite pencils, kneaded eraser, watercolors, small round brushes, Titanium White watercolor, cotton swab, red pastel pencil

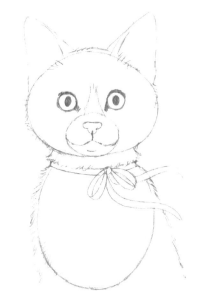

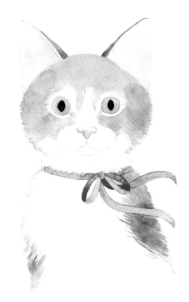

1 Begin by sketching the kitten on tracing paper, then transfer to hot-pressed watercolor paper. Only transfer the most necessary lines so you have less to erase later.

2 Lay in the base colors with watercolor. I used paints by Holbein. Use washes of Raw Umber for the brown fur, and Raw Sienna for the inside of the ears. The eyes are Olive Green with a black pupil. The nose is Shell Pink, and the ribbon is Lilac. Try to leave the white areas of fur as plain paper.

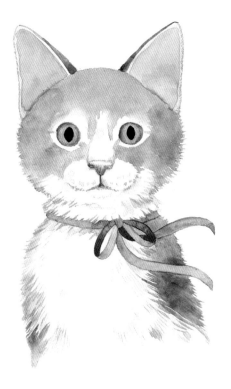

3 Dilute Davy's Gray and use it to add shading and definition to the white fur. Add a layer of Shell Pink to the insides of the ears, and shade the nose with Burnt Sienna. Add a soft rim of Raw Sienna to the eyes.

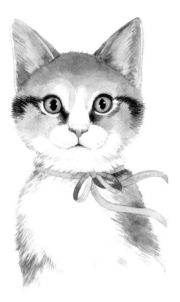 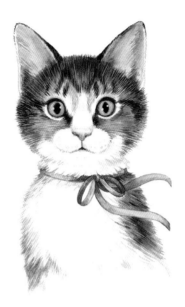

4 Begin adding detail to the insides of the ears with Raw Sienna, and start adding to the fur stripes with Sepia. Paint the rim of the eyes with Sepia and blend with clean water on the brush. Add a little more Olive Green around the pupil, and when dry, dot in the Titanium White highlights.

5 Build up the fur with Raw Umber and Sepia. Your breastwork should be featherlight and taper at the ends. Add details to the ribbon with violet.

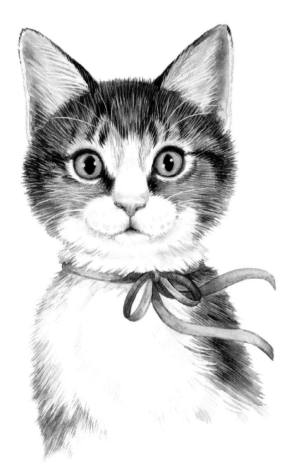

6 Dilute Titanium White to the consistency of cream, and use it to add white fur and whiskers. For an extra touch of softness, pick up a little red on a cotton swab by rubbing it on the tip of a red pastel pencil, then rub the color into the mouth and ears. You can do the same with a graphite pencil to add softness to the white fur.

Orange Cat

For the fluffy orange fur of this kitten, I used Faber-Castell pastel pencils as well as watercolor. Combining the two mediums helps add softness to the shading.

MATERIALS

hot-pressed watercolor paper, graphite pencils, kneaded eraser, large lid, watercolors, small round brushes, pastel pencils, cotton swabs, Titanium White watercolor

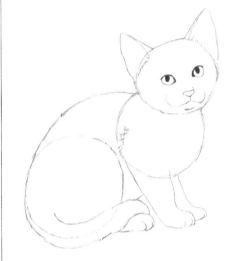

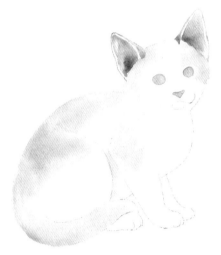

1 Lightly sketch the kitten onto a sheet of hot-pressed (smooth) watercolor paper. You can also use the tracing paper and transfer method. I used a large lid as a stencil for the basic shapes.

2 Lay in your base colors with watercolor washes. I have used Raw Sienna for the orange fur, Raw Umber inside the ears, Shell Pink for the nose and Olive Green for the eyes.

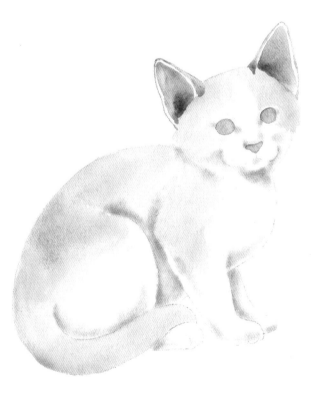

3 For this step, you need a cotton swab and a brown pastel pencil. Rub the swab across the pencil to pick up some pigment. Use the swab like a paintbrush to rub the pigment into the paper to create shading.

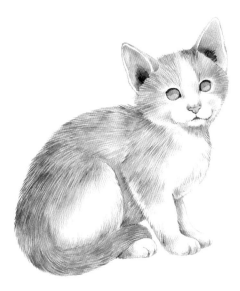

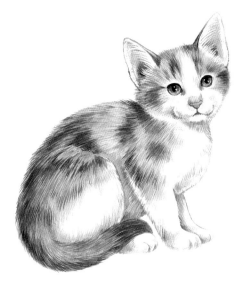

4 With a small round brush, outline the eyes with Sepia watercolor and shade with Raw Umber. Build up the white fur with strokes of Raw Umber and the orange fur with Raw Sienna. Your fur strokes should follow the direction of hair growth.

5 Develop the eye with a bit more Olive Green. Then add a black pupil. Use Titanium White for the highlights of the eye and the hairs in the ears. Build up more layers of fur with Burnt Umber and Raw Sienna.

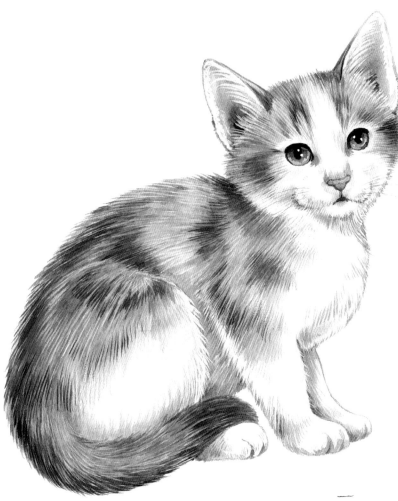

6 Lightly blend the fur with clean water on the brush. Add a few white hairs with Titanium White. Add touches of pink to the mouth and ears with pink pastel on a cotton swab. Draw whiskers with a 2H pencil.

Dog Studies

Dogs are fun to draw. There is so much variety between the breeds that I never get bored. And puppies are so full of charm and personality!

Just like humans, animals—especially dogs—can have expressive faces. Ear position, eyes and the shape of the mouth all give clues to the dog's emotions.

When drawing puppies, remember that they have different proportions than adult dogs. I like to put them in a playful pose because that is how we think of puppies— always engaging and lively!

Dog Anatomy

The canine family has the most variety between breeds of any mammal. Each type of dog has special characteristics that set it apart, such as fur length or texture, ear or muzzle shape, or body size.

Puppies have eyes that are large, round and often dark. The fur starts at the eye and grows outward.

The hair growing up from the nose meets and overlaps the hair at the bottom of the eye. Dog and puppy nostrils are comma shaped. This is called the "alar fold."

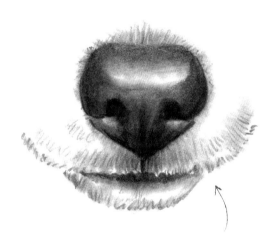

A healthy dog has a wet nose, so add highlights for shine.

Some puppies have upright ears, and some have ears that flop over. And some puppies have one of each! The ears can add a lot of personality to your puppy portrait.

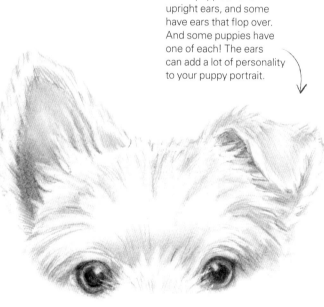

Puppies often have oversized paws compared to their adult selves. It is worth practicing drawing feet, rather than trying to hide them in grass or leaves. Your drawing will be much more convincing if you can include the feet.

Fluffy Orange Puppy

This puppy is very soft and fluffy, so I added a base coat of color with pastel pencils and PanPastels to give me a soft layer to build upon.

MATERIALS

bristol board or mixed-media paper, tracing paper, graphite pencils, kneaded eraser, pastel pencils, cotton swab, fixative, colored pencils, small round brush, Titanium White watercolor

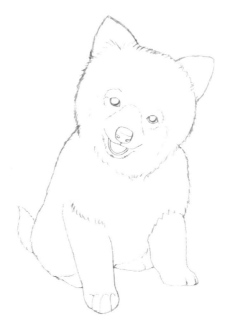

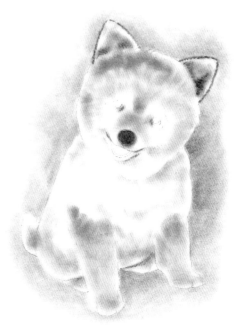

1 Sketch your drawing on a sheet of tracing paper and transfer it onto a sheet of smooth bristol board or mixed-media paper with an HB pencil.

2 Fill in a vignette around the puppy with purple pastel, blended with a cotton swab. Add the first layer of fur with various shades of ochre and brown pastel pencils and an Orange Shade PanPastel. You may want to lightly spray the drawing with fixative at this point, or keep a scrap of tracing paper under your hand to prevent smearing.

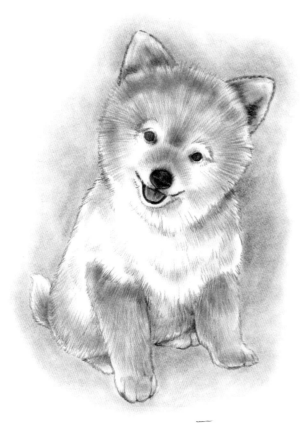

3 Add fur strokes with Burnt Sienna and Terracotta colored pencils. The darkest areas are Van Dyke Brown.

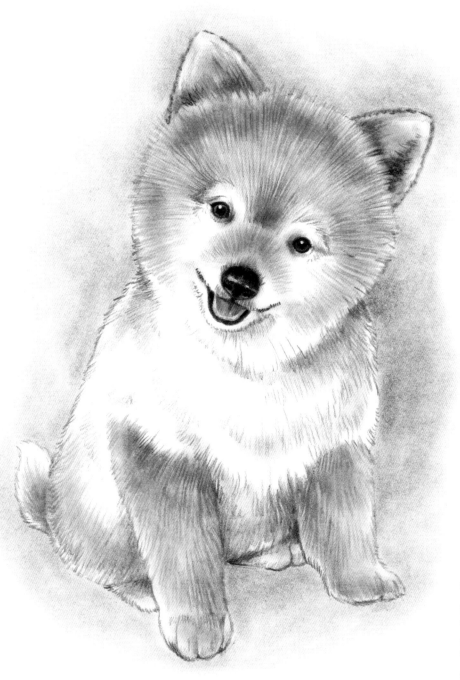

4 Add pupils to the eyes and details to the nose with a black colored pencil. Use Titanium White watercolor for the highlights. Continue building up the fur with sharp colored pencils. You may wish to use a pencil with a harder lead for this step, such as a Prismacolor Verithin or a Marco Raffine.

Labrador Puppy

This puppy has short, smooth fur, so I decided to do the first layer of shading with water-soluble graphite and a brush. You could also use a regular pencil and blend it with a tortillion until it is smooth.

MATERIALS

bristol board, graphite pencils, kneaded eraser, water-soluble graphite, small round brush, tracing paper, tortillion, Titanium White watercolor

1 Sketch your puppy with a 2H pencil and transfer it onto a sheet of bristol board.

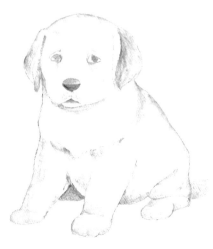

2 Begin shading the basic forms of the puppy with water-soluble graphite and a no. 10 round brush.

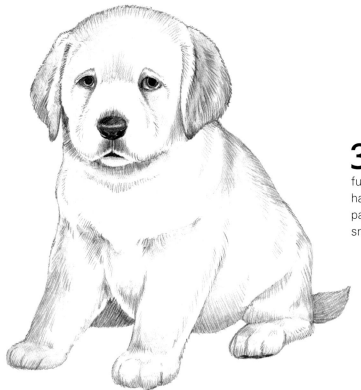

3 Begin developing the fur with a 2B pencil. Use short, delicate fur strokes that go in the direction of hair growth. Keep a scrap of tracing paper under your hand to help prevent smearing.

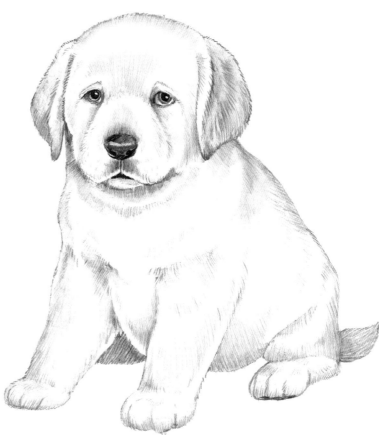

4 Continue adding fur with a 2H pencil. Blend with a tortillion when finished. Add highlights to the eyes and nose with a dab of white watercolor and a small brush.

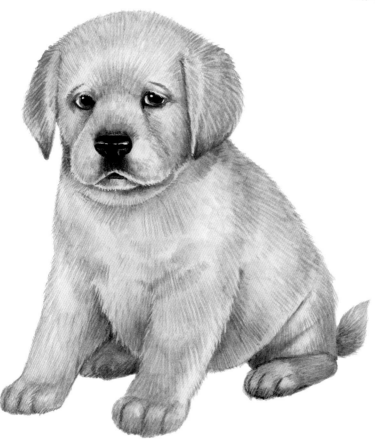

If you wish, you can do this puppy in watercolor pencils too. I painted a basecoat with Raw Sienna watercolor. Then I used Caran Dache Supracolor pencils in Sepia, Burnt Ochre and Cinnamon, and Faber Castell Albrecht Durer pencils in Brown Ochre and Black. Details were added with Verithin pencils in Goldenrod and Dark Brown. I used Titanium White water-color for the highlights.

Fluffy White Dog

White fur is a challenge because you need to draw the shadows around the fur, rather than the fur itself. In this demonstration I left some of the white areas as the plain paper, but also used some opaque Titanium White watercolor.

MATERIALS

cold-pressed watercolor paper or mixed-media paper, tracing paper, graphite pencils, kneaded eraser, watercolors, small and large round brushes, Titanium White watercolor

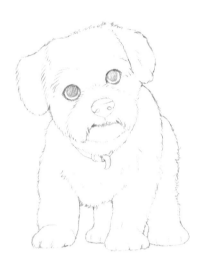

1 Draw the dog on tracing paper and transfer to cold-pressed watercolor paper or mixed-media paper. If any of your transferred lines are too dark, gently lift them with a kneaded eraser.

2 Carefully wet the paper around the dog with a large round brush. While it is still wet, paint a wash of Cerulean Blue, Indigo and Payne's Gray.

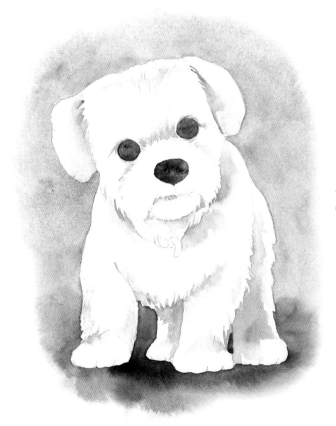

3 Paint the eyes with Burnt Umber, and shade the ears with Raw Umber. Mix Raw Umber and Payne's Gray to paint the gray shading.

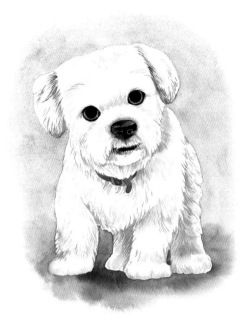

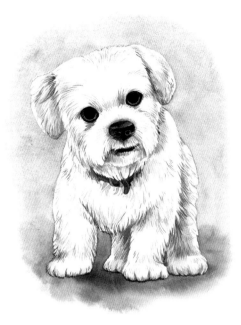

4 Paint the pupils, nose and mouth with black. The collar is Cadmium Red Hue (the word *hue* in the name means that it is a nontoxic version of the color) and Payne's Gray. Continue building up the fur with your gray mixture. Paint the fur around the nose and mouth and on the ears with diluted Sepia.

5 Continue building up the fur. Add a bit of Cadmium Red Hue to your gray mix and use it to shade the collar.

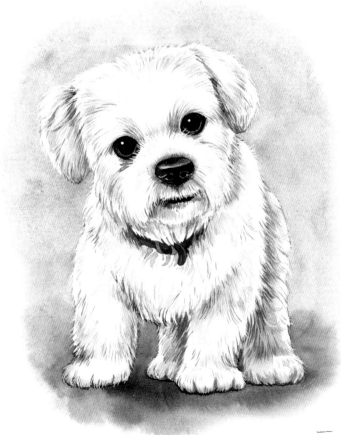

6 Add some thin washes of Raw Umber to warm up some of the shaded areas. Paint the highlights on the eyes and nose with Titanium White. If desired, add some delicate white hairs on the dog. Make sure that some overlap the eyes.

Fox and Wolf Studies

Foxes, wolves and coyotes are all part of the canine family. They have had close associations with man for thousands of years. Who hasn't heard of the lone wolf or a clever fox? Foxes have learned to live alongside man, even in the city, so they are a fairly common sight. Wolves have not fared as well, but their populations are making a comeback.

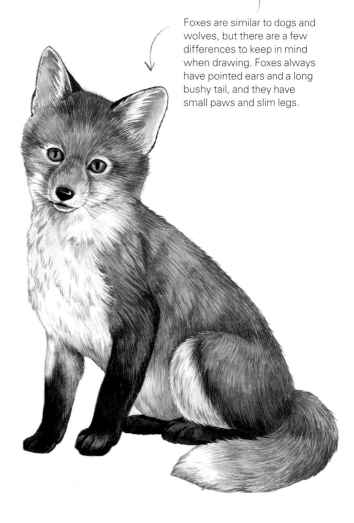

Foxes are similar to dogs and wolves, but there are a few differences to keep in mind when drawing. Foxes always have pointed ears and a long bushy tail, and they have small paws and slim legs.

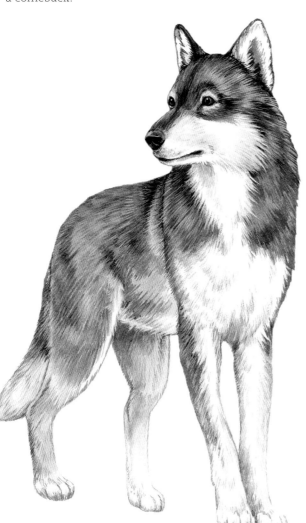

Wolf

Wolves have such a magnetic expression. I wanted to try to capture that, so I decided to focus just on the head for a portrait in pastel. If you are going to buy only two colors, go with Raw Umber and Orange Shade by PanPastel. I use these two most often.

MATERIALS

bristol board, graphite pencils, tracing paper, kneaded eraser, PanPastels, eye shadow applicator, colored pencils, small round brush, Titanium White watercolor

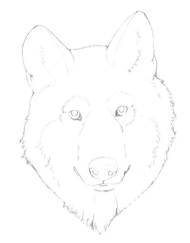

1 Sketch the wolf's head on tracing paper and transfer it to a sheet of smooth bristol board.

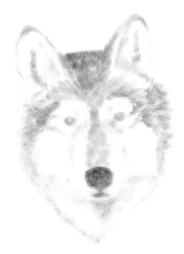

2 Fill in your base layer with Raw Umber and Orange Shade pastels. Apply with eye shadow applicators or PanPastel Sofft Tools. You could also use pastel pencils and a cotton swab.

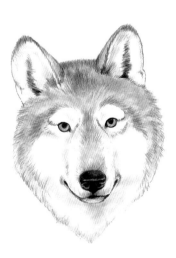

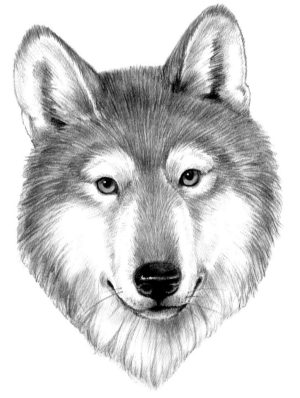

3 Place a scrap of tracing paper under your hand to help prevent smearing. Add details with a black colored pencil. Shade the top of the eyes with a Goldenrod Prismacolor colored pencil.

4 Continue building up the fur with Raw Umber, 50% Warm Gray and Goldenrod colored pencils. Add highlights and a few white hairs with Titanium White watercolor. Draw a few whiskers with a very sharp black pencil.

Fox Wearing a Hat

Add cuteness to your animal drawings by incorporating human elements. This is called "anthropomorphizing." In this demonstration, giving this sweet baby fox a little hat and scarf adds to his charm. Anthropomorphized animals are common in book and greeting card illustrations. For this project I wanted to show that you don't need the most expensive art supplies in order to get a good result. Here I used Hero watercolor pencils in my sketchbook.

MATERIALS

mixed-media paper, graphite pencils, tracing paper, kneaded eraser, watercolor pencils, small round brushes, Titanium White watercolor

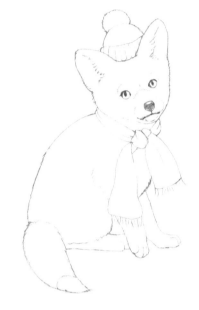

1 Sketch the fox and transfer him to a sheet of mixed-media paper. Notice that the hat curves on the top of the head; it is not a line straight across. The scarf also curves and hangs around the neck.

2 Fill in the fox with Sand Brown watercolor pencil. The paws, nose and other dark areas are Dark Brown. Do not color too heavily; you don't want the color to be too dark at this step. The hat is True Blue, the scarf is Grass Green and the eyes are Clay Brown.

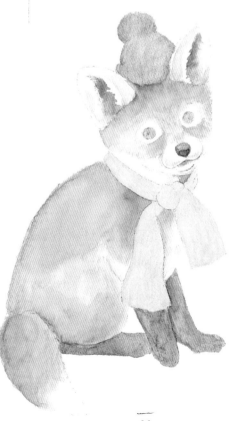

3 Go over each color with a clean, damp brush, letting each color dry before you wet the color next to it. After you have gone over the dark brown areas, use the pigment that is left on your brush to add a little shading to the ears, muzzle and chest. You can load more pigment onto your brush if necessary by wiping the brush across the tip of the pencil.

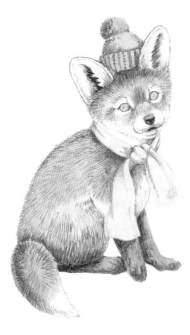

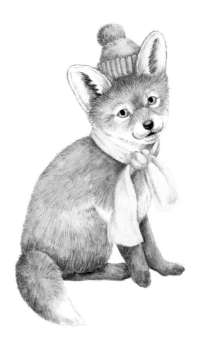

4 Make sure the fox is completely dry, then add shading. Use Sand Brown and Dark Brown on the fur, with some Pale Brown on the back. Use Teal Blue on the hat, Olive Green on the scarf and Pale Red in the white fur areas.

5 Go over the fox again with a damp brush. Use very little water. You don't want to blend out all the fur strokes so that they don't show. Let some remain. Add the pupils and detail the nose and mouth with black.

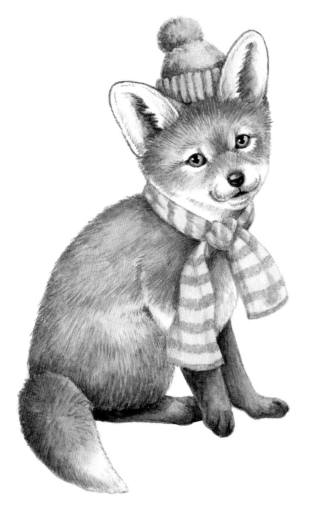

6 Continue adding and building up the layers. Add stripes to the scarf with Moss Green and highlights with Titanium White watercolor. Let it dry completely between layers.

Forest Animal Studies

In North America we encounter many wild animals in our forests and parks. Deer, raccoons and skunks—they live all around us!

Only male deer have antlers. They are shed and regrown each year, and continue growing throughout the animal's life. Antlers are made of bone, unlike horns, which are made of similar material to our fingernails.

Squirrels, skunks and raccoons are animals that live from coast to coast in the U.S. They can been seen in our gardens and parks, but it is best to observe from a distance.

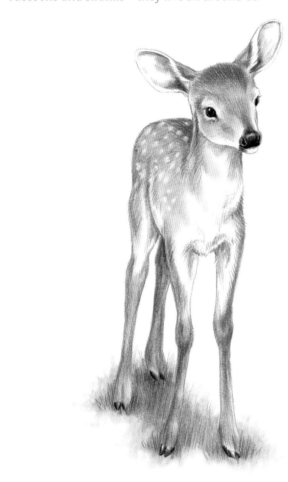

Baby Skunk

Once I was camping and I heard a little boy in a nearby campsite say, "Oh look, a kitty cat!" The next thing I heard was a yell, and then the smell came drifting through the trees. But even with their stinky reputation, a baby skunk is still very cute!

MATERIALS

bristol board, graphite pencils, kneaded eraser, pastel pencils, cotton swab, tracing paper, blender pen, white colored pencil, small round brush, Titanium White watercolor

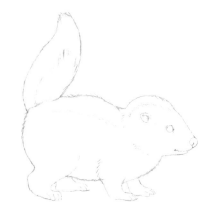

1 Transfer your sketch onto a sheet of drawing paper or bristol board.

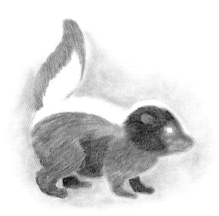

2 Draw a green vignette around the skunk with a pastel pencil and blend with a cotton swab. Fill in the dark fur on the skunk with a Dark Grey pastel pencil, and blend. Leave the white fur as plain paper.

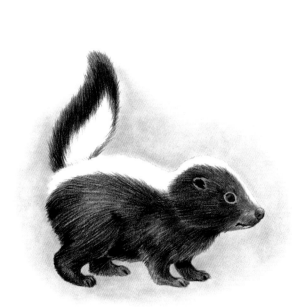

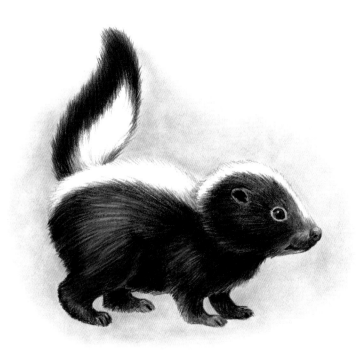

3 Fill in the eyes and nose with a Burnt Umber colored pencil. Draw the black fur with a black colored pencil, following the direction of fur growth. Keep a scrap of tracing paper under your hand to protect against smearing.

4 Add a little shading to the white fur with the Burnt Umber pencil. Go over the lighter areas of the black fur with a White Prismacolor pencil. Blend with a blender pen. Finally, add highlights to the eyes and nose with Titantium White watercolor.

Fawn

Gouache is a type of opaque watercolor. While watercolors tend to dry lighter than they look when wet, gouache paint dries darker. This makes them perfect for dark colored papers, as they create a dramatic result. I used black bristol paper here and Holbein gouache paints.

MATERIALS

black bristol paper, tracing paper, white transfer paper, graphite pencils, kneaded eraser, gouache paints including Titanium White, small round brush

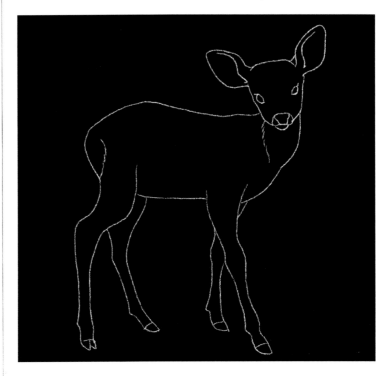

1 Sketch your fawn on a sheet of tracing paper and transfer it to the black paper with white transfer paper.

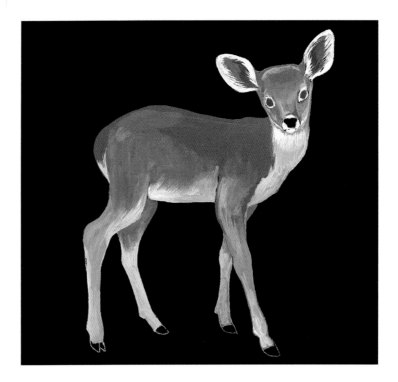

2 Paint the base colors with gouache paints. Mix Raw Sienna and Burnt Umber for the body, then gradually add Ivory White to the mix as you paint down the legs. Mix Burnt Umber and Titanium White for the darker shading, for the eyes and inside the ears. Use Titanium White for the muzzle, around the eyes and the ears.

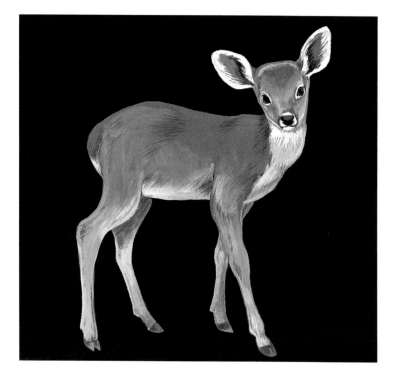

3 Add darker fur strokes with diluted Sepia gouache. Add details to the nose and hooves with Neutral Grey #3. Detail the eyes and muzzle with black.

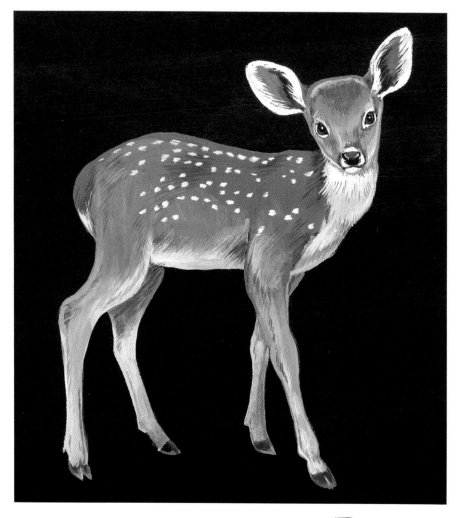

4 Use Ivory White to add a few strokes of light fur. Finally, paint in the spots with Titanium White, and add highlights to the eyes and nose.

Rodent Studies

When I first think about super cute animals, I immediately picture mice, squirrels, hedgehogs and the like. You can't go wrong if you decide to add one of these little cuties to your drawings!

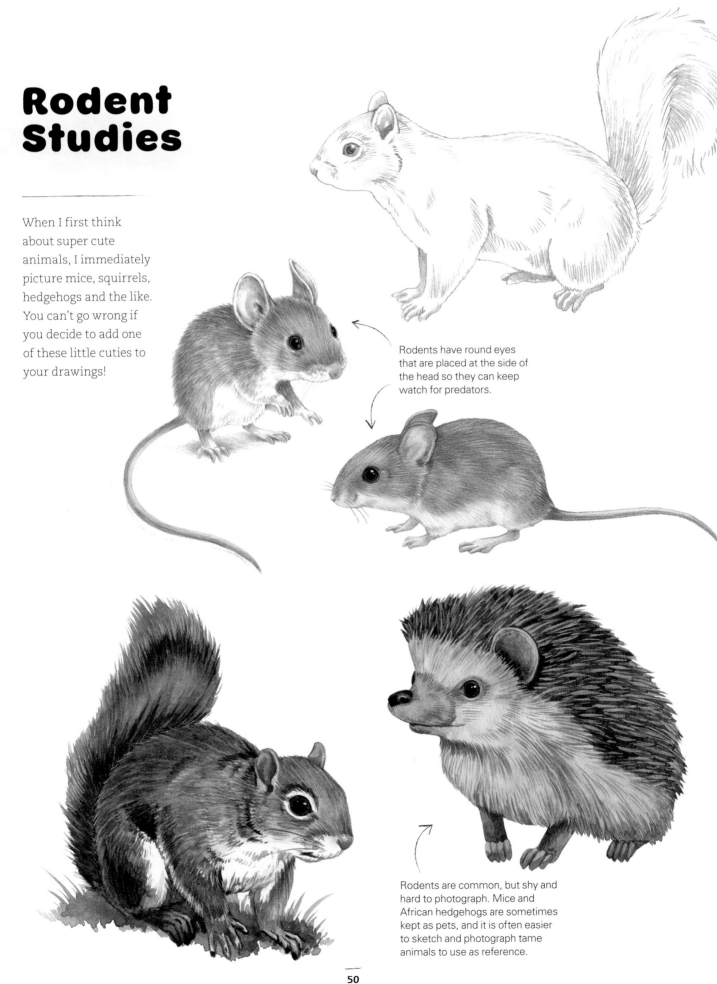

Rodents have round eyes that are placed at the side of the head so they can keep watch for predators.

Rodents are common, but shy and hard to photograph. Mice and African hedgehogs are sometimes kept as pets, and it is often easier to sketch and photograph tame animals to use as reference.

Chipmunk

Chipmunks are striped little creatures who live primarily in North American forests. They are famous for their cheek pouches, which can stretch to store nuts and seeds. I always think they have friendly little faces, and they can become quite tame in campgrounds where people tend to feed them.

MATERIALS

bristol paper, graphite pencils, kneaded eraser, scrap paper, tortillion or cotton swab

1 Begin by sketching or transferring the basic outline of the chipmunk onto smooth bristol paper.

2 With a very sharp 2H pencil, draw in the first layer of fur. Use short strokes that follow the direction of hair growth. Leave a highlight when filling in the eye.

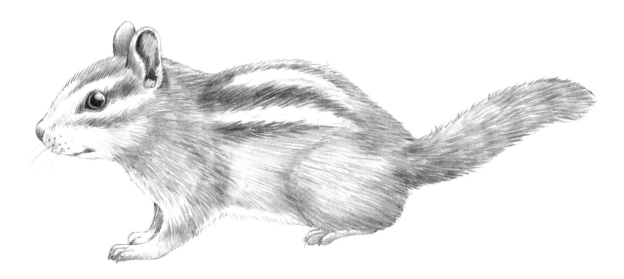

3 With a 4B pencil, fill in the darker hairs, the stripes and the pupil of the eye. Keep a piece of scrap paper under your hand to avoid smearing. Use a 2H pencil to add details like whiskers, then blend the fur with a tortillion or cotton swab.

Mouse

In this demonstration you will paint watercolor over pen lines, so make sure to use waterproof ink such as a felt-tipped drawing pen (Pigma Micron is a common brand). You could also use waterproof ink for this project and a crow quill dip pen (I prefer Higgins brand ink). Make sure to do a couple of test lines on scrap paper after dipping your pen in the ink so you don't accidentally blot on your drawing.

MATERIALS
bristol board, graphite pencils, kneaded eraser, felt-tip drawing pen, watercolor, round brushes

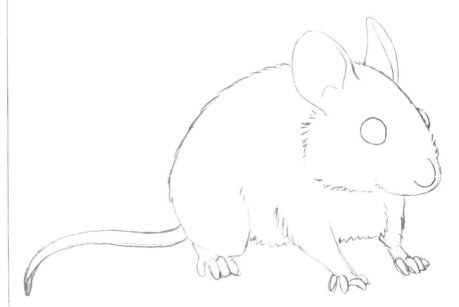

1 Transfer your sketch onto a sheet of smooth bristol board with graphite pencil.

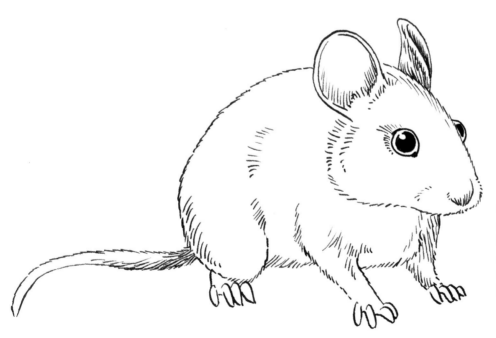

2 Begin drawing the fur on the mouse with a felt-tip drawing pen, following the direction of fur growth. After you draw the outline, let the ink dry thoroughly, then erase your pencil lines with a kneaded eraser.

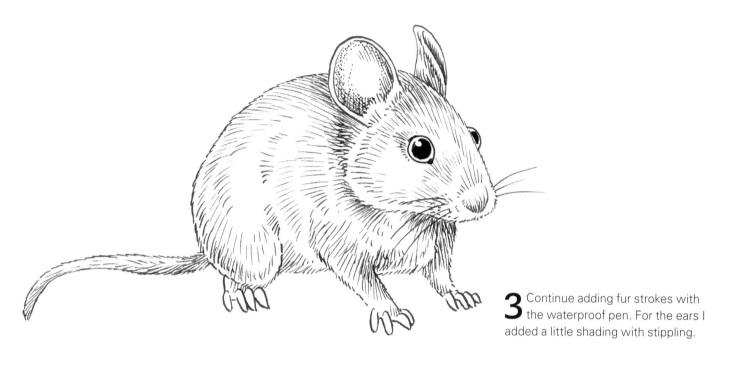

3 Continue adding fur strokes with the waterproof pen. For the ears I added a little shading with stippling.

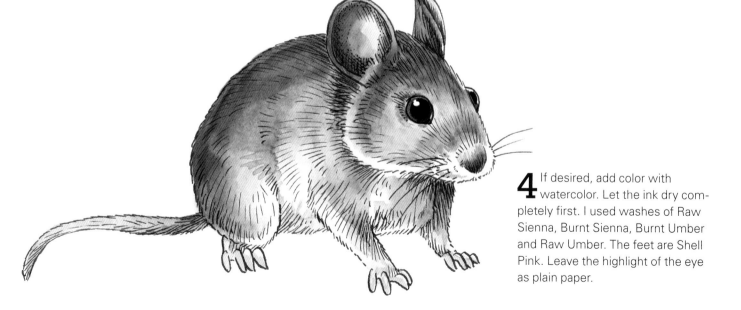

4 If desired, add color with watercolor. Let the ink dry completely first. I used washes of Raw Sienna, Burnt Sienna, Burnt Umber and Raw Umber. The feet are Shell Pink. Leave the highlight of the eye as plain paper.

Squirrel

Sometimes it is fun to draw or paint on an unusual surface. I collect vintage papers for this reason. For this project I chose a sheet of ledger paper from 1815 and primed it with Daniel Smith Watercolor Ground. This seals the surface and gives it a slight texture for the watercolor paint to grip onto. Let the page dry for a full day after priming. I wanted a subject matter that would go with the vintage paper, so I chose a red squirrel. These charming animals are becoming quite rare due to gray squirrels taking over their habitat.

MATERIALS

vintage paper, watercolor ground, transfer paper, tracing paper, graphite pencils, watercolors, round brushes, Titanium White watercolor

1 Draw your sketch on a sheet of tracing paper and transfer it to the page with graphite transfer paper. Be careful to avoid smudges; they are very hard to remove. I was surprised at what big feet red squirrels have!

2 Paint a vignette around the squirrel with Cerulean Blue and Chromium Oxide Green watercolor. Paint the squirrel with a wash of Raw Sienna, and the tree trunk and squirrel's eye with Raw Umber.

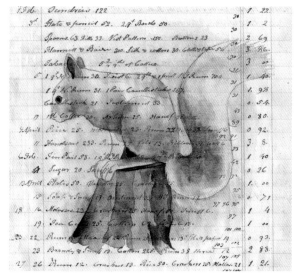

3 Begin developing the form of the squirrel with washes of Burnt Sienna and Raw Umber. Add shading to the tree stump with Sepia. Add a pupil to the eye with black watercolor.

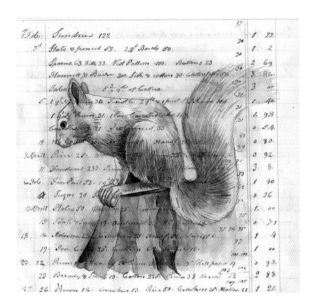

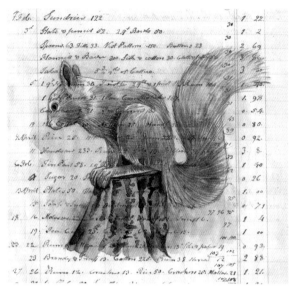

4 Using delicate fur strokes, begin developing the fur in the darker areas of the squirrel with Raw Umber. Add a bit more color to the vignette.

5 Mix Burnt Sienna and Raw Sienna together in equal measures and paint the reddish fur. Blend a little with clean water on the brush. Add more details to the tree stump with Sepia.

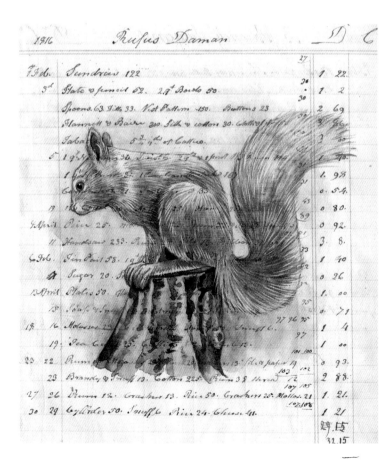

6 Mix Raw Sienna with Titanium White to paint the lightest fur. Add a highlight to the eye with Titanium White. Mix the white with Raw Umber to paint the light areas on the tree stump.

Nature Studies

When you are doing drawings of small animals, it is a good idea to think about other elements you can put in your drawing to make it a scene, instead of just an animal by itself. I like to do studies of leaves and other natural things in my sketchbooks so I have them to refer to when I am planning a drawing or painting.

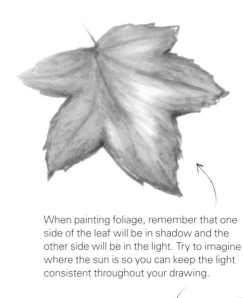

When painting foliage, remember that one side of the leaf will be in shadow and the other side will be in the light. Try to imagine where the sun is so you can keep the light consistent throughout your drawing.

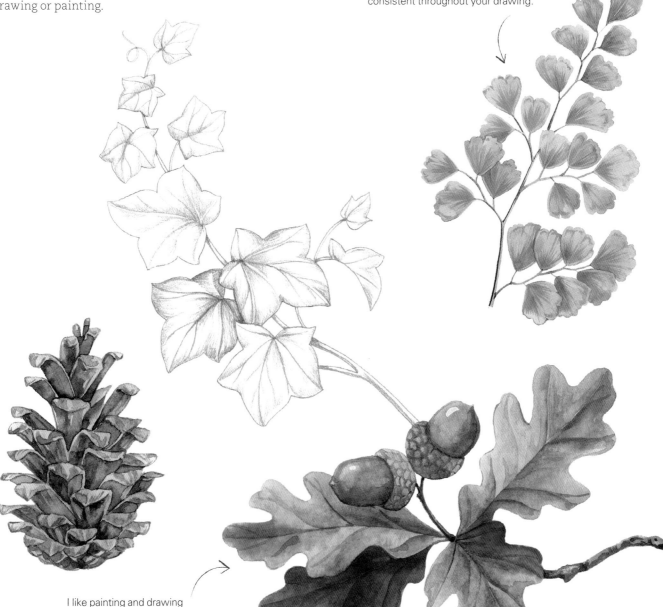

I like painting and drawing autumn leaves best because of all the variety of color.

Leaf

For this project let's draw a simple maple leaf with a waterproof pen, such as Pigma Micron. I also used watercolor pencils for the color.

MATERIALS
bristol board, waterproof pen, watercolor pencils, small round brushes, tissue

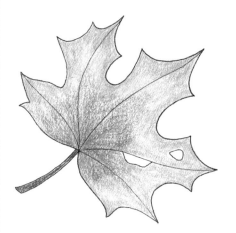

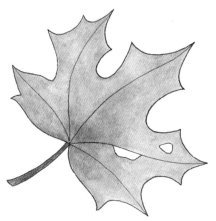

1 Start by drawing a simple maple leaf with a waterproof pen. Loosely color the leaf with an Olive Green watercolor pencil, blending out to a golden yellow at the edges. Use less pressure when coloring the transition area from green to yellow so it is a bit lighter. The stem is Burnt Sienna.

2 Wet a round brush with clean water. Start at the bottom of the leaf and work your way outward, blending the color with the water.

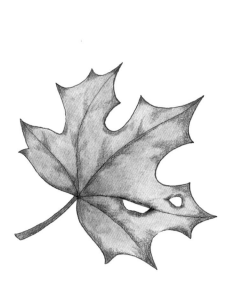

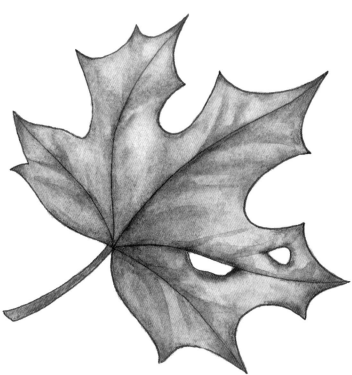

3 When the paint is dry, color the edges and tips with Russet and Burnt Sienna pencils. Add shading with a brown pencil.

4 Your brush should be only slightly damp for this step. Carefully go over the Russet and brown areas, blending them outward. To lighten some areas, use clean water and blot with a tissue.

Farm Animal Studies

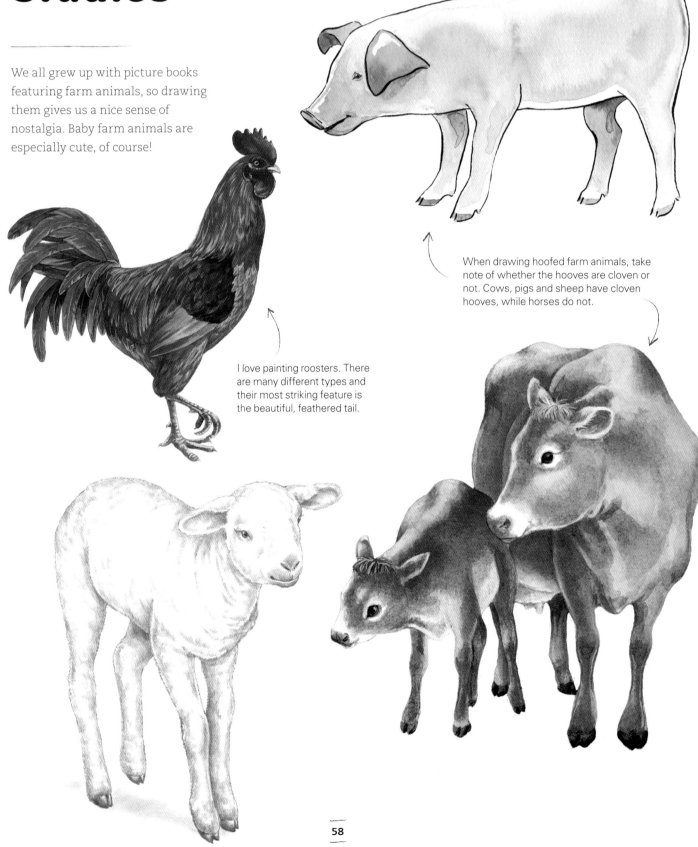

We all grew up with picture books featuring farm animals, so drawing them gives us a nice sense of nostalgia. Baby farm animals are especially cute, of course!

I love painting roosters. There are many different types and their most striking feature is the beautiful, feathered tail.

When drawing hoofed farm animals, take note of whether the hooves are cloven or not. Cows, pigs and sheep have cloven hooves, while horses do not.

Lamb

The most important attribute of a lamb is the softness of the fleece. You will need to do a lot of blending with a tortillion for the best results. I prefer to use a dirty tortillion that already has graphite built up.

MATERIALS

bristol board, tracing paper, graphite pencils, kneaded eraser, scrap paper, tortillion

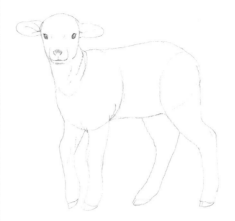

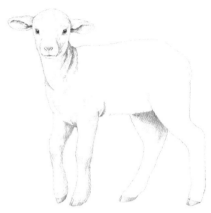

1 Begin by sketching the lamb with a 2H pencil. Transfer only the most necessary lines lightly to a sheet of smooth bristol board.

2 Use delicate scribble strokes to begin filling in the fleece on the lamb. I used 2H and 3B pencils. Put a sheet of scrap paper under your hand to avoid smudging.

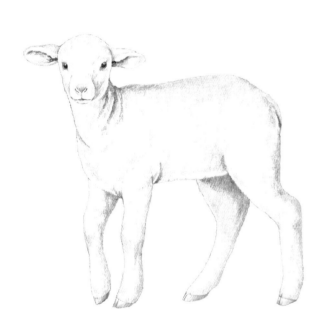

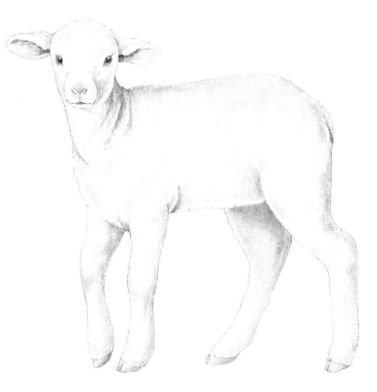

3 Continue shading the lamb with scribble strokes.

4 Gently blend with a tortillion. Use circular strokes rather than going from side to side.

Ducklings

Tinted paper can give your drawings an extra pop. I chose blue Mi-Teintes paper here because the blue evokes a watery environment. It also offsets the warm colors of the ducklings. Making the ducklings interact gives an extra dimension of cuteness to the drawing. I used Caran d'Ache Luminance pencils for this project. Prismacolor would also be a good choice. You want a pencil that is quite opaque.

MATERIALS

blue vellum paper, white transfer paper, colored pencils, black fine-point pen, blender pen, small round brush, Titanium White watercolor or white gel pen

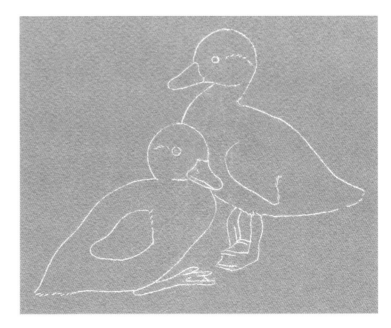

1 To begin, I transferred my drawing to the surface using white transfer paper.

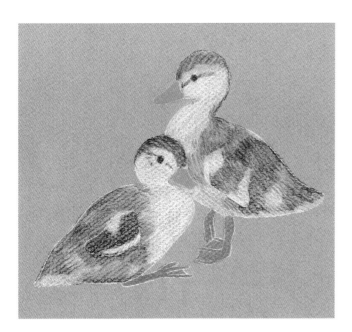

2 Lay in the base colors with Naples Ochre, Bismuth Yellow and Burnt Sienna for the feathers. Use Violet Grey for the beak and Brown Ochre for the legs.

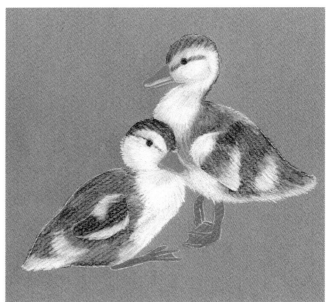

3 Fill in the light colors with Buff Titanium, Yellow Ochre and White. You will need to do several layers to cover the blue background.

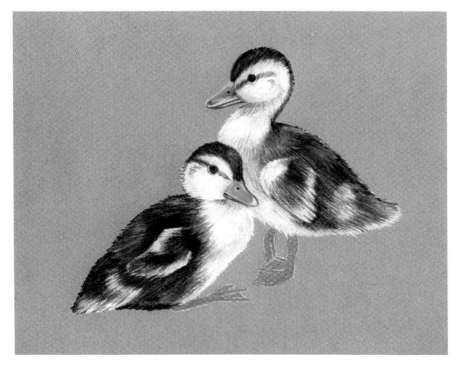

4 Use a Sepia pencil to add the dark feather strokes. Go over the dark feathers in places with Buff Titanium to highlight them slightly. Add a pupil to the eyes with a black Pigma Micron pen.

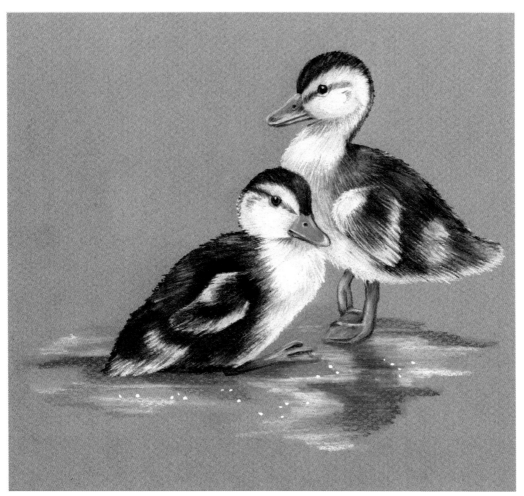

5 Finish the legs with Burnt Sienna, Bismuth Yellow and Buff Titanium. For the ground, use Olive Brown, Olive Brown 50%, Yellow Ochre and White. If desired, you can blend the drawing with a blender pen. Add the final highlights with Titanium White water-color or a white gel pen.

Donkey

There is a legend that donkeys are marked with a cross on their backs because Mary rode on a donkey to Bethlehem. They do indeed have a cross-shaped area of darker fur, but I don't know if that is the reason. They have lovely soft, fluffy coats, especially when they are young. I chose a combination of pastel and regular Faber-Castell pencils for this drawing to help capture the softness. Just for fun, you could even try using colored eyeshadow for the pastel layer.

MATERIALS

bristol board, graphite pencils, kneaded eraser, tracing paper, colored pencils, pastel pencils, cotton swabs or eyeshadow applicators

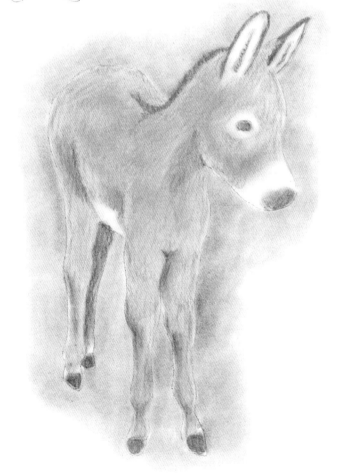

1 Sketch the donkey onto tracing paper and transfer it onto a sheet of smooth bristol board.

2 Color a vignette around the donkey with purple pastel, and blend with cotton swabs or eyeshadow applicators. Color the donkey with two different browns—one light and one dark—and blend. Leave the white areas as plain paper.

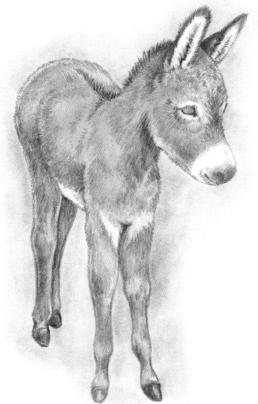

3 You will now want to keep a scrap of tracing paper under your hand to prevent smudging. Start building up the fur with Burnt Umber and Brown Ochre colored pencils. I used short scribble strokes for most of the shading. Lift out lighter areas with an eraser.

4 Add more shading and details with Brown Ochre and Black pencils.

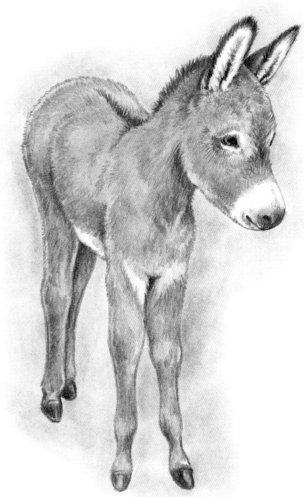

Pig

Pigs are genetically close to humans, so it is no surprise that they have expressive faces and a certain pudgy charm. I used Faber-Castell Albrecht Dürer watercolor pencils for this drawing.

MATERIALS

bristol board or mixed-media paper, graphite pencils, kneaded eraser, tracing paper, watercolor pencils, round brushes

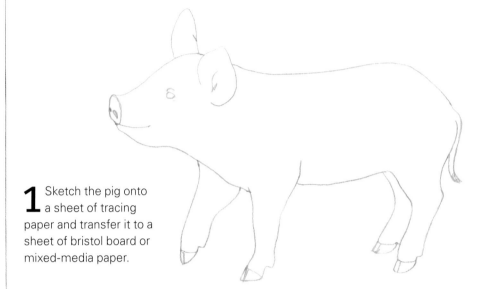

1 Sketch the pig onto a sheet of tracing paper and transfer it to a sheet of bristol board or mixed-media paper.

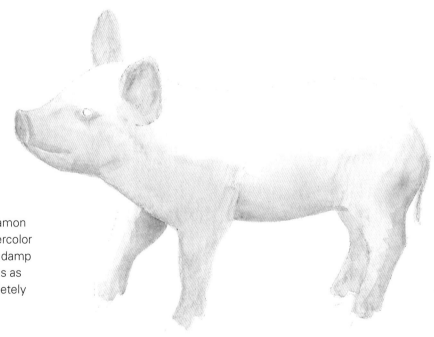

2 Color the pig with Cinnamon and Rose Carmine watercolor pencils. Blend with a clean, damp brush. Leave the white areas as plain paper. Let it dry completely before the next step.

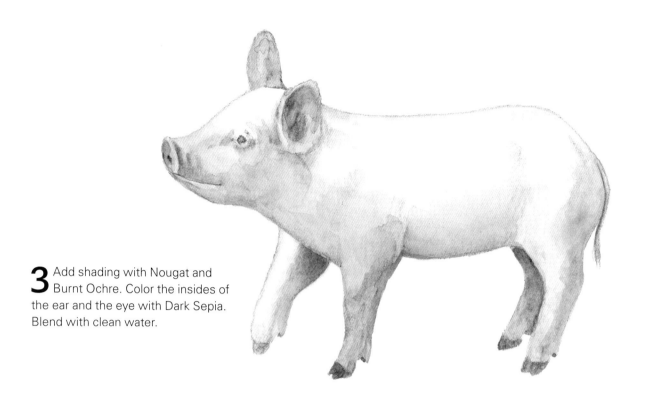

3 Add shading with Nougat and Burnt Ochre. Color the insides of the ear and the eye with Dark Sepia. Blend with clean water.

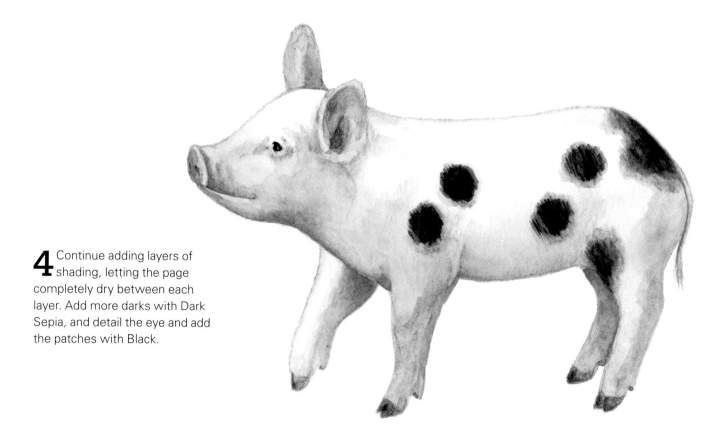

4 Continue adding layers of shading, letting the page completely dry between each layer. Add more darks with Dark Sepia, and detail the eye and add the patches with Black.

Bird Studies

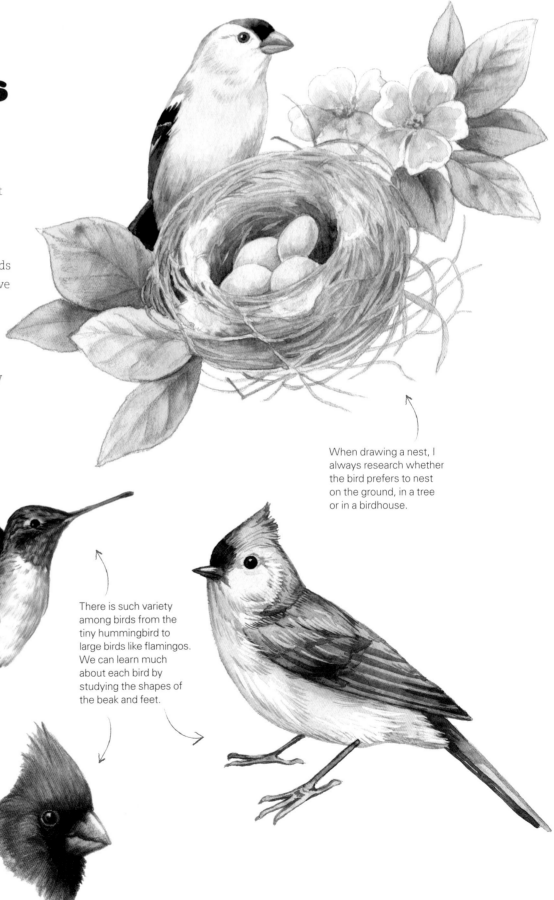

If you were to ask me what subject I draw or paint most frequently, I would have to answer, "Birds!" No matter where you live—city or country—there are songbirds that share our habitats. I love the great variety in shape and color in the bird world. At first I found birds the most challenging thing to draw, but I am very glad I persevered.

When drawing a nest, I always research whether the bird prefers to nest on the ground, in a tree or in a birdhouse.

There is such variety among birds from the tiny hummingbird to large birds like flamingos. We can learn much about each bird by studying the shapes of the beak and feet.

66

Bird Anatomy

Birds can be difficult to draw. One of the most important things to pay attention to is the shape of the beak. For example, insect eaters like this bluebird have longer, more pointed bills, while seedeaters have thicker, stronger beaks for cracking open seeds. Also pay attention to the wing. Remember that there is a solid structure underneath the feathers, and that all the feathers are not identical in size and shape. Make sure you do not place the eye too far forward, a common mistake.

Crown

Bill

Nape

Back

Scapulars

Primaries

Breast

Belly

Seedeater's beak

Adding Natural Elements

I love nature. I find it really helps me draw an animal or bird if I do some studies on its life and habitat. When I take walks, I am always filling my pockets with interesting leaves, acorns, and other treasures!

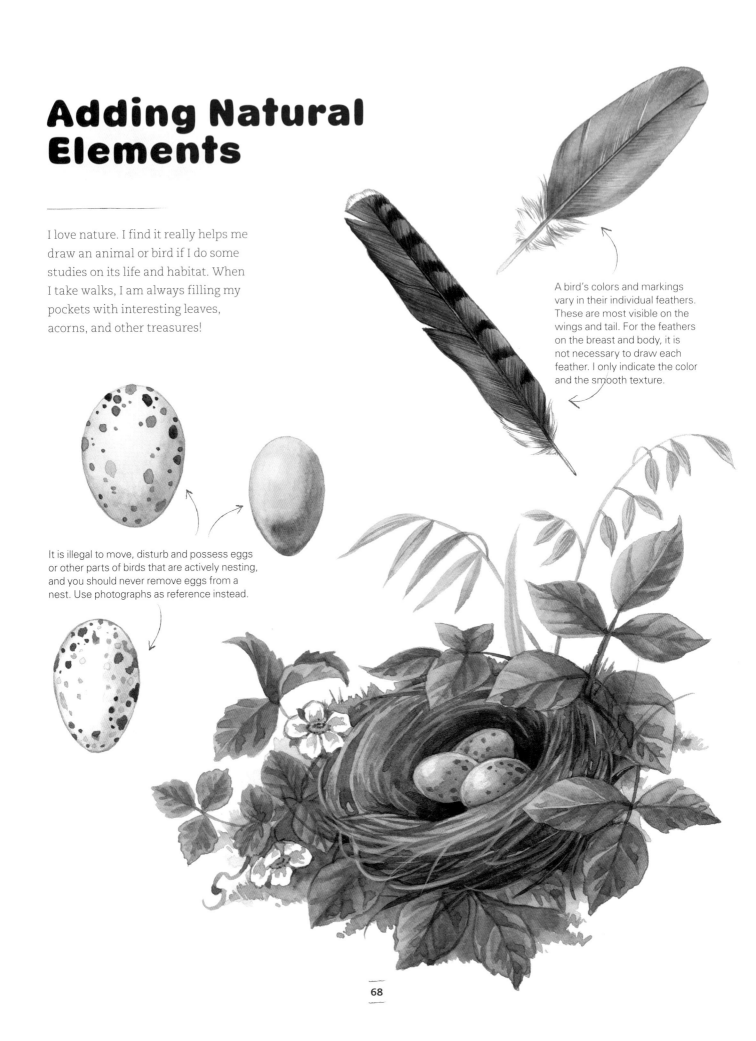

A bird's colors and markings vary in their individual feathers. These are most visible on the wings and tail. For the feathers on the breast and body, it is not necessary to draw each feather. I only indicate the color and the smooth texture.

It is illegal to move, disturb and possess eggs or other parts of birds that are actively nesting, and you should never remove eggs from a nest. Use photographs as reference instead.

Titmice

Titmice are among my favorite birds. They have large, dark eyes and perky habits. Like cardinals they have a crest on their heads that varies in shape according to the position of the head. Unlike many birds, male and female titmice do not differ in appearance.

MATERIALS

hot-pressed watercolor paper, graphite pencils, kneaded eraser, watercolors, small round brushes, Titanium White watercolor

1 Sketch the birds with pencil on hot-pressed watercolor paper. Paint washes of Payne's Gray and Raw Sienna watercolor on the birds' bodies, diluting with plenty of water until thin. Paint the eye with Burnt Umber and the beak and legs with Payne's Gray (using less water).

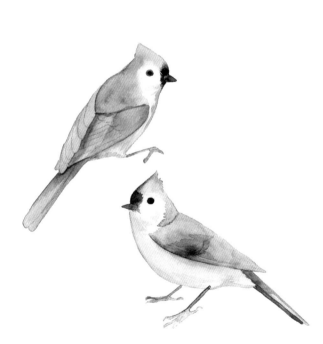

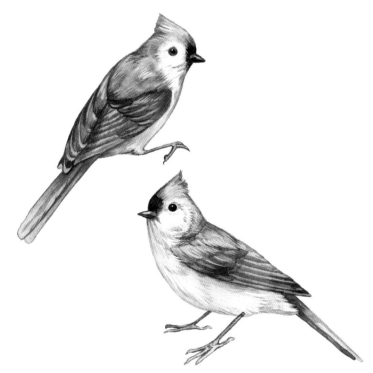

2 Mix Payne's Gray with Raw Umber, dilute with water, and use it to shade the breast and belly. Use Payne's Gray with less water to shade the wings and tail. Add Raw Umber around the beak and a black pupil to the eye.

3 Using a small round brush, add details with Payne's Gray, Raw Umber and Titanium White. Use very little water when diluting the paint for this step.

Flamingo

The flamingo is the quintessential summer bird. They are fun and quirky, and I love their colors! The pink color comes from the tiny shrimp they eat. For this drawing I used Faber-Castell Albrecht Dürer water-soluble pencils.

MATERIALS
mixed-media paper, graphite pencils, kneaded eraser, transfer paper, water-soluble colored pencils, small round brush, paper towel, black fine-point pen

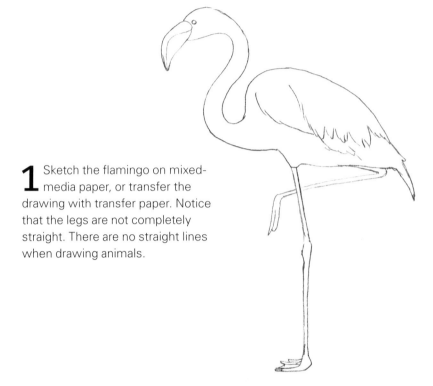

1 Sketch the flamingo on mixed-media paper, or transfer the drawing with transfer paper. Notice that the legs are not completely straight. There are no straight lines when drawing animals.

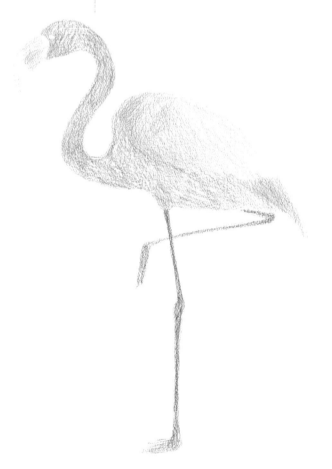

2 Color the base coat of the flamingo. I used Dark Flesh, Rose Carmine and Orange Glaze water-soluble colored pencils. The legs are Venetian Red.

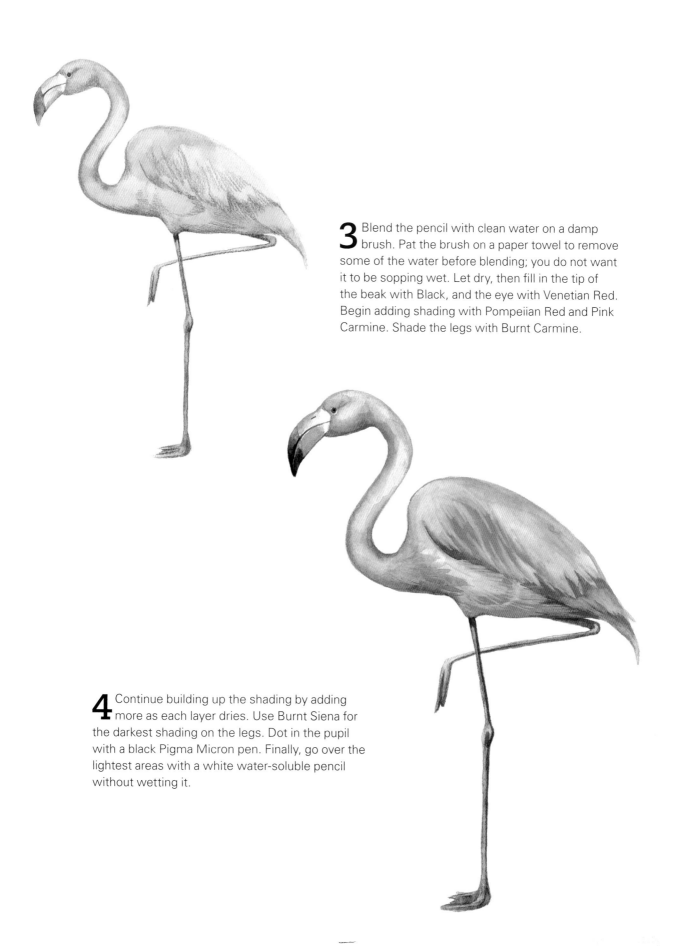

3 Blend the pencil with clean water on a damp brush. Pat the brush on a paper towel to remove some of the water before blending; you do not want it to be sopping wet. Let dry, then fill in the tip of the beak with Black, and the eye with Venetian Red. Begin adding shading with Pompeiian Red and Pink Carmine. Shade the legs with Burnt Carmine.

4 Continue building up the shading by adding more as each layer dries. Use Burnt Siena for the darkest shading on the legs. Dot in the pupil with a black Pigma Micron pen. Finally, go over the lightest areas with a white water-soluble pencil without wetting it.

Chickadee

Chickadees just might be my favorite birds. They have cute, lively personalities and are easy to attract to bird feeders. For this drawing you will need a selection of graphite pencils: 4H, 2H and 2B.

MATERIALS

bristol board, graphite pencils, kneaded eraser, tracing paper

1 Sketch your bird onto tracing paper with a 4H pencil and transfer it to a sheet of smooth bristol board.

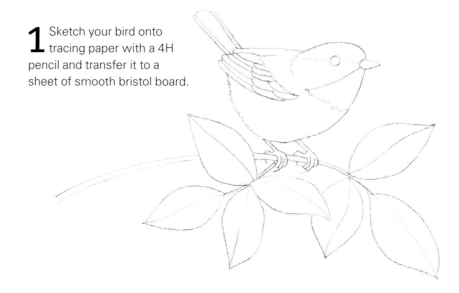

2 Begin building up tones with a 2H pencil. Notice that only one side of each leaf is in shadow.

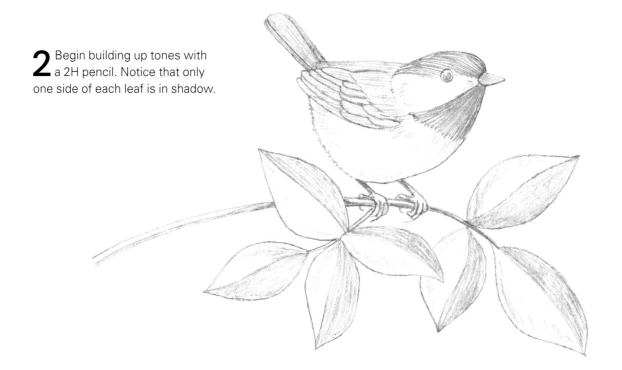

3 Blend with a tortillion, then use the dirty side of the tortillion to rub shading into the white areas.

4 Add the darkest details with a sharp 2B pencil. The lighter shading is done with a 2H pencil.

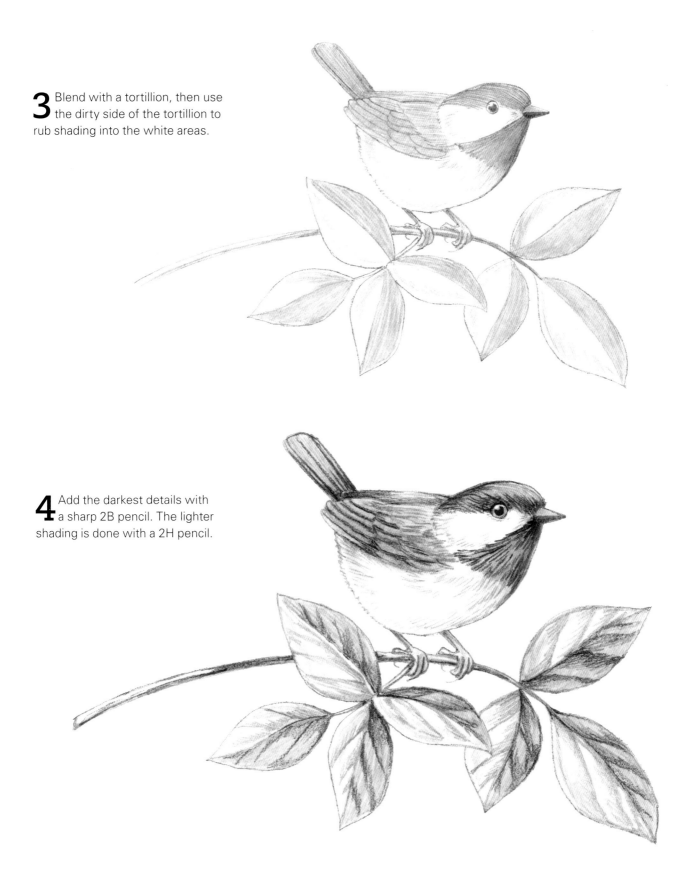

Goldfinch

If you want to create convincing drawings of birds, it is a good idea to spend some time photographing them and sketching them from life. I like to observe them from bird feeders in my garden. Goldfinches are one of the most frequent visitors, so I draw them often.

MATERIALS

bristol board, graphite pencils, kneaded eraser, colored pencils, blender pen, small round brush, Titanium White watercolor

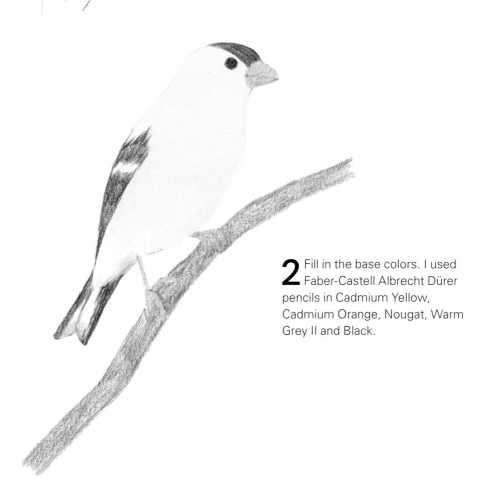

1 Sketch the goldfinch onto a sheet of smooth bristol board with a 2H pencil. Pay special attention to the line of the beak and the black cap on his head. It is easy to make birds look a little bit angry when you draw them, but adjusting these areas can make them look cuter. Go over the lines with a kneaded eraser to lift them, as you don't want them to be too dark.

2 Fill in the base colors. I used Faber-Castell Albrecht Dürer pencils in Cadmium Yellow, Cadmium Orange, Nougat, Warm Grey II and Black.

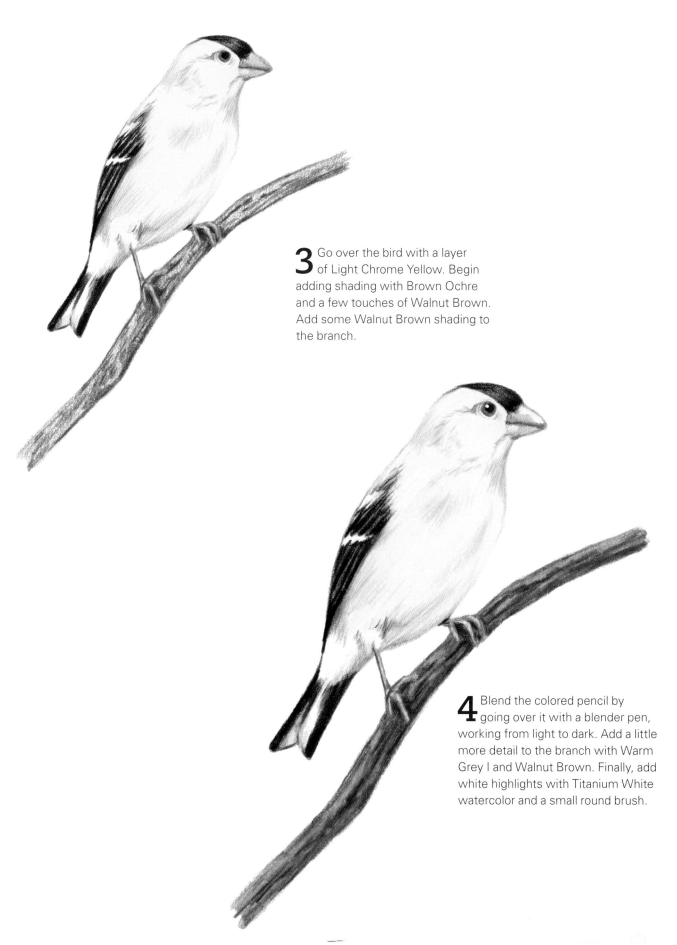

3 Go over the bird with a layer of Light Chrome Yellow. Begin adding shading with Brown Ochre and a few touches of Walnut Brown. Add some Walnut Brown shading to the branch.

4 Blend the colored pencil by going over it with a blender pen, working from light to dark. Add a little more detail to the branch with Warm Grey I and Walnut Brown. Finally, add white highlights with Titanium White watercolor and a small round brush.

Owl

I chose gray-toned mixed-media paper for this piece because I thought the gray would play well against the muted colors in the owl. When painting on darker paper, it's best to use an opaque medium to cover the paper. For this project I used Holbein gouache watercolors.

MATERIALS

gray mixed-media paper, graphite pencils, kneaded eraser, tracing paper, transfer paper, gouache paints, small round brushes

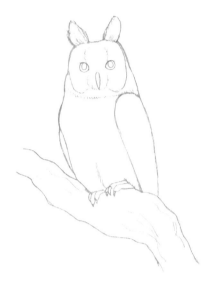

1 Draw your owl onto tracing paper and transfer onto the gray paper. You can use either white or graphite transfer paper.

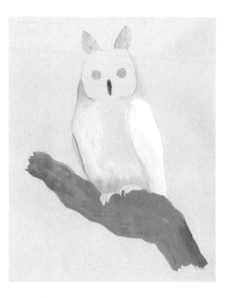

2 Mix Grey #2 and Grey #3 together in equal measure and paint the tree branch and the beak. Mix various tints of Sepia and Permanent White and begin painting the body. The eyes are Yellow Ochre.

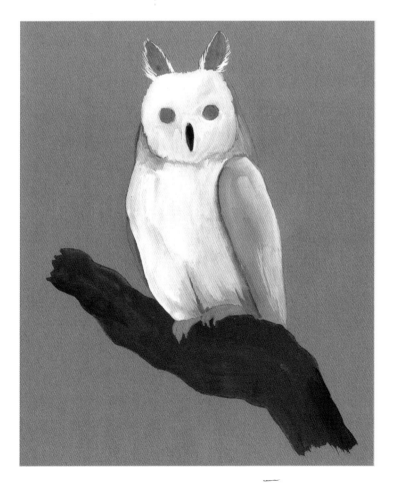

3 Fill in the body and head with Permanent White. Shade under the wings with Grey #3. The feet are a mix of Raw Umber and Permanent White.

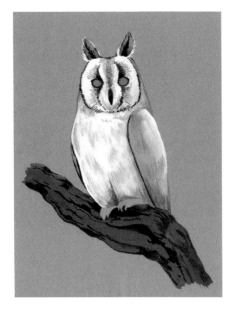

4 Begin adding details with Raw Umber. Add darker details over the top with Sepia. Mix Sepia and Grey #3 for the dark areas on the branch.

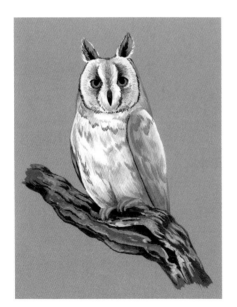

5 Mix various combinations of Burnt Umber, Sepia and Permanent White and use them to develop the feathers. Paint the pupils and the tip of the beak with Black. Mix Grey #2 and Permanent White to paint the lighter areas on the branch.

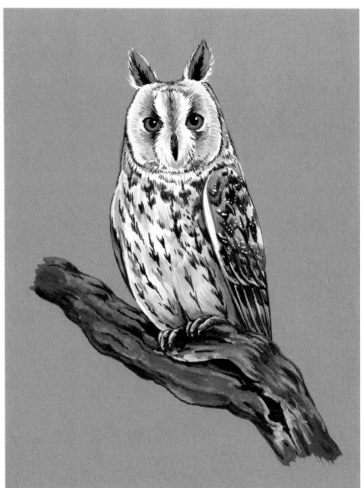

6 Finish adding dark details with Sepia. Paint highlights with Permanent White. Finally, add a thin glaze of diluted Sepia to areas on the branch.

Sea Creature Studies

I wish I lived closer to the sea. Beachcombing is one of my favorite activities. Whenever I draw or paint sea creatures, I am always reminded of happy times spent by the ocean. I often choose watercolor to render these subjects because it seems appropriate for such a watery theme.

When most of us think of the sea, we think of the warm, tropical ecosystems. Coral reefs, exotic shells and brightly colored fish abound. But surprisingly, seabirds such as seagulls and pelicans can be found far inland.

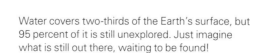

Water covers two-thirds of the Earth's surface, but 95 percent of it is still unexplored. Just imagine what is still out there, waiting to be found!

Background Elements

If you want to paint sea creatures, it is a good idea to also practice drawing items that exist in the surroundings, such as shells, coral and seaweed. Shells are so much fun to paint, with such color and variety!

I love the way seaweed looks underwater. There is an amazing variety of colors to add to your underwater seascapes.

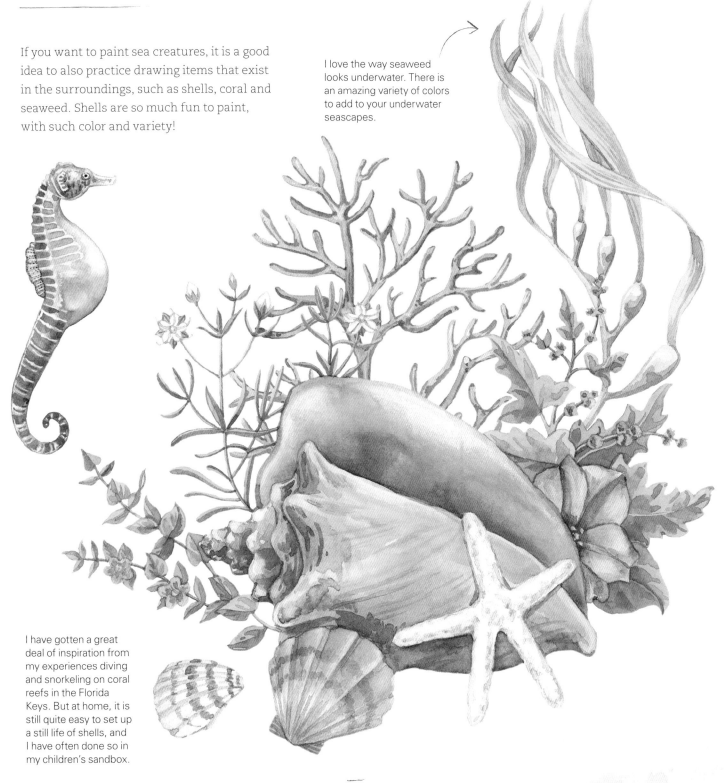

I have gotten a great deal of inspiration from my experiences diving and snorkeling on coral reefs in the Florida Keys. But at home, it is still quite easy to set up a still life of shells, and I have often done so in my children's sandbox.

Dolphin

Dolphins are sleek and shiny, so I thought it would be a good idea to use a wet medium for this drawing. I chose Faber-Castell Albrecht Dürer water-soluble pencils.

MATERIALS

bristol board or mixed-media paper, graphite pencils, kneaded eraser, water-soluble colored pencils, small round brush, Titanium White watercolor

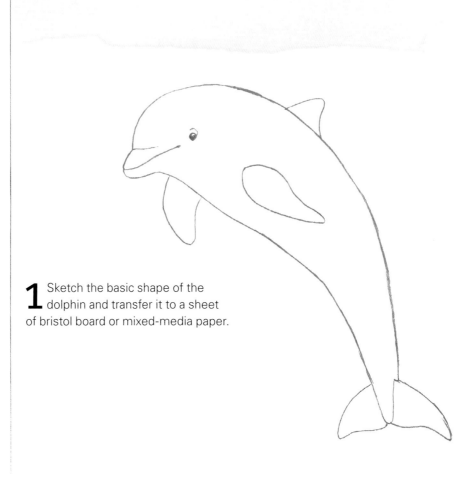

1 Sketch the basic shape of the dolphin and transfer it to a sheet of bristol board or mixed-media paper.

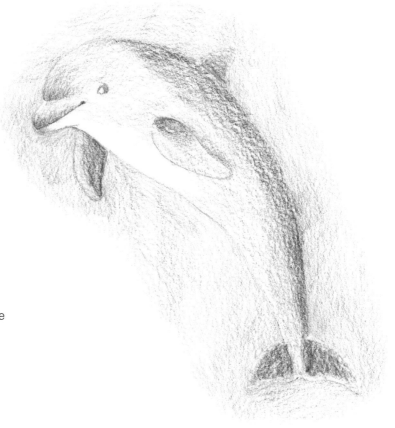

2 Lightly color a vignette around the dolphin with Cobalt Green. Add some Light Phthalo Blue at the bottom of the vignette. Fill in the dolphin with Cold Grey III and Cold Grey V. Leave some white paper on the belly. Add a little Light Ultramarine along the back.

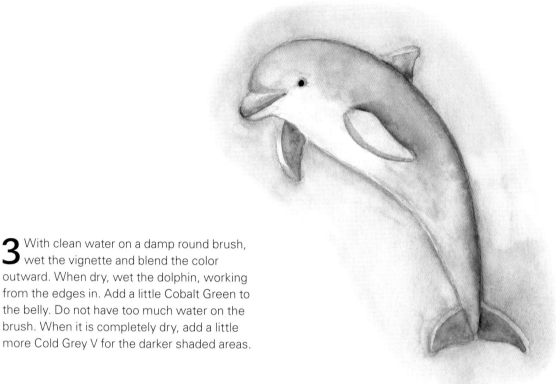

3 With clean water on a damp round brush, wet the vignette and blend the color outward. When dry, wet the dolphin, working from the edges in. Add a little Cobalt Green to the belly. Do not have too much water on the brush. When it is completely dry, add a little more Cold Grey V for the darker shaded areas.

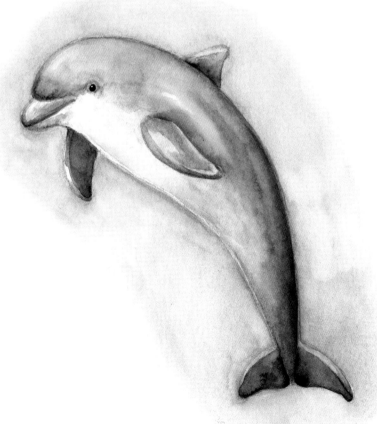

4 Continue building up the shading with Payne's Gray and Dark Indigo. Add highlights with Titanium White watercolor and a small round brush.

Puffin

Puffins are one of my favorite birds. I was able to spend a fantastic day on the Farne Islands in England watching and photographing these little charmers. You will notice the word "hue" after some of the colors I chose. Colors like Cadmium Orange can be toxic. Hue means that it is a nontoxic version of the color.

MATERIALS

hot-pressed watercolor paper or mixed-media paper, graphite pencils, kneaded eraser, tracing paper, watercolors, small round brushes, Titanium White watercolor

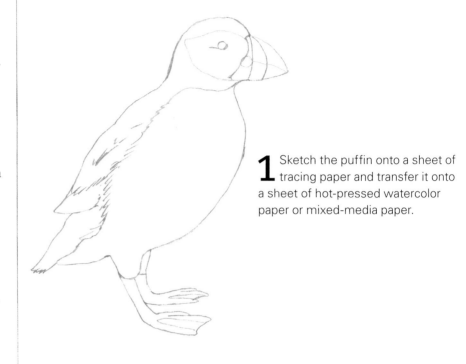

1 Sketch the puffin onto a sheet of tracing paper and transfer it onto a sheet of hot-pressed watercolor paper or mixed-media paper.

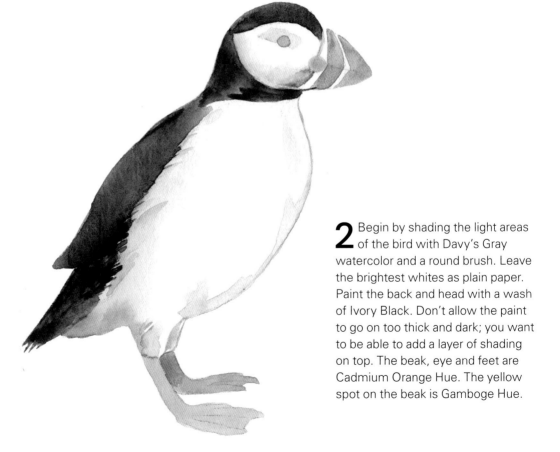

2 Begin by shading the light areas of the bird with Davy's Gray watercolor and a round brush. Leave the brightest whites as plain paper. Paint the back and head with a wash of Ivory Black. Don't allow the paint to go on too thick and dark; you want to be able to add a layer of shading on top. The beak, eye and feet are Cadmium Orange Hue. The yellow spot on the beak is Gamboge Hue.

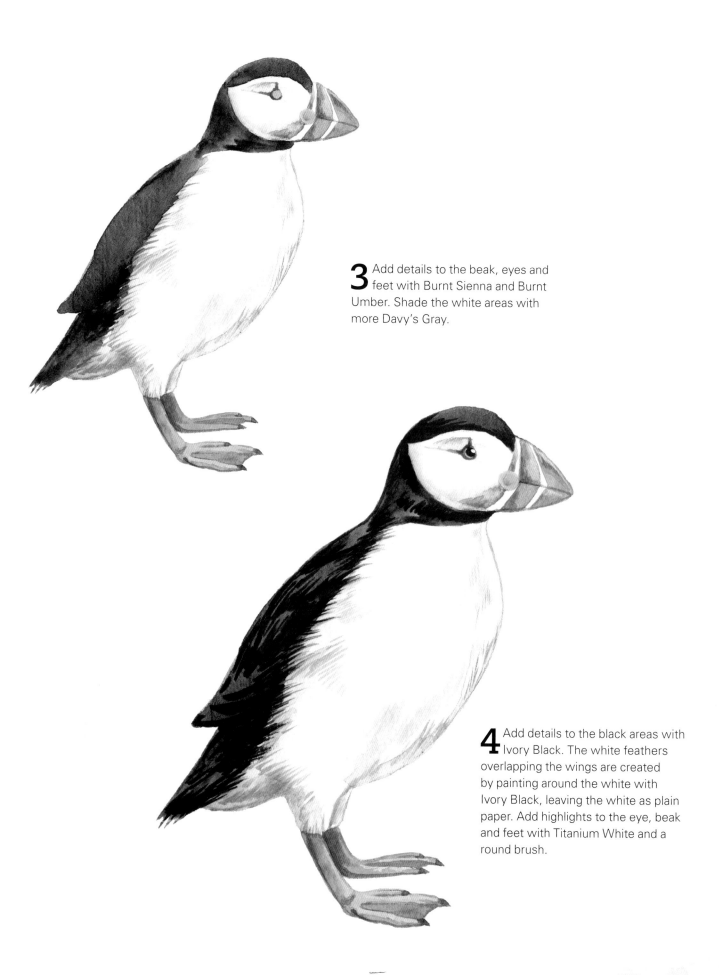

3 Add details to the beak, eyes and feet with Burnt Sienna and Burnt Umber. Shade the white areas with more Davy's Gray.

4 Add details to the black areas with Ivory Black. The white feathers overlapping the wings are created by painting around the white with Ivory Black, leaving the white as plain paper. Add highlights to the eye, beak and feet with Titanium White and a round brush.

Seal

Baby seals are so cute with their fluffy coats and large, dark eyes. Pastels and colored pencils are a good choice for trying to capture their softness.

MATERIALS

bristol board or mixed-media paper, graphite pencils, kneaded eraser, pastels, PanPastels, eye shadow applicators or PanPastel Sofft tools, colored pencils, small round brush, Titanium White watercolor, cotton swab

1 Sketch the seal with a 2H pencil and transfer it to bristol board or mixed-media paper.

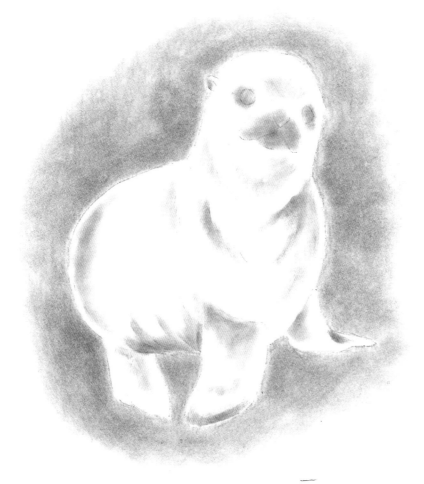

2 Fill in the background vignette with a Turquoise PanPastel and eye shadow applicators or PanPastel Sofft Tools. Begin shading the seal with Raw Umber PanPastel.

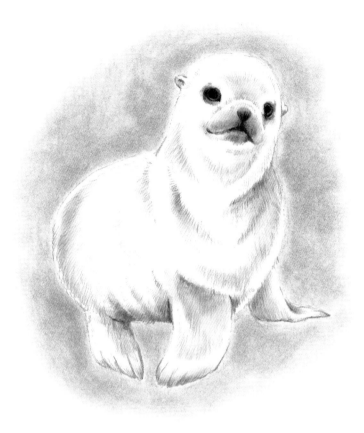

3 Add details with Sepia and Burnt Umber colored pencils. Use black for details of the eyes, nose and mouth.

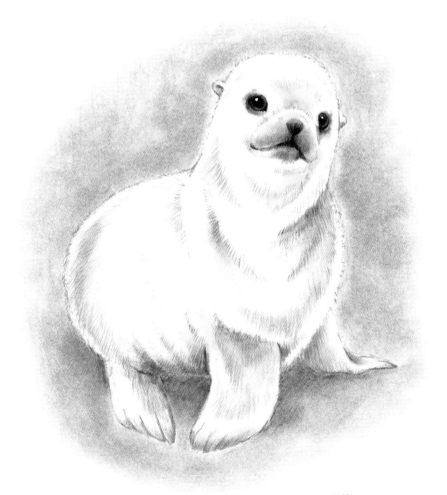

4 Soften the edges of the seal with a kneaded eraser. Add highlights to the eyes with Titanium White watercolor. Add a shadow under the seal with dark blue pastel and blend with a cotton swab.

Bear Studies

I live in the Rocky Mountains of Colorado, but I rarely see bears in the wild. I think I'm glad about that, to be honest! I love to paint bears, but I wouldn't want to share my picnic with one!

Black bears are the most common bears in the United States. They are smaller than grizzly bears and do not have the large shoulder hump.

A lot of people don't realize that bears are omnivores—they eat meat as well as plants and berries. That means you can place them in a variety of environments in your drawings.

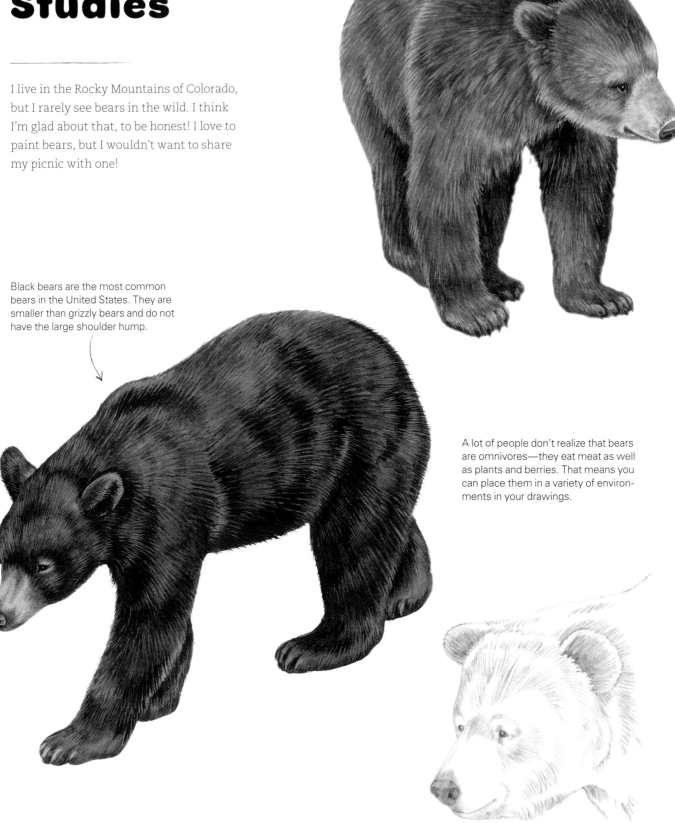

Panda

I thought the softness of pastel pencils would be perfect to render the soft fur of this young panda. For this piece I used Faber-Castell pastel pencils along with Prismacolor pencils on toned mixed-media paper from Stillman & Birn. You could also substitute kraft paper if needed.

MATERIALS

toned mixed-media paper, graphite pencils, kneaded eraser, pastel pencils, colored pencils, cotton swabs, tortillions, white gel pen

1 Transfer your sketch. Your mixed-media paper needs to have a little bit of tooth so the pastel can cling to it.

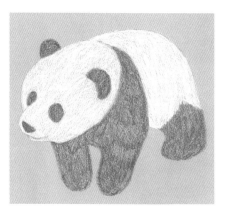

2 Fill in the basic shapes of the panda with white and dark gray pastel pencils.

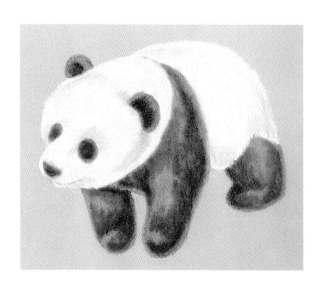

3 Blend the pastel with cotton swabs or tortillions. Use a separate one for the white and for the black. Add shading with medium gray and black pastel. Blend.

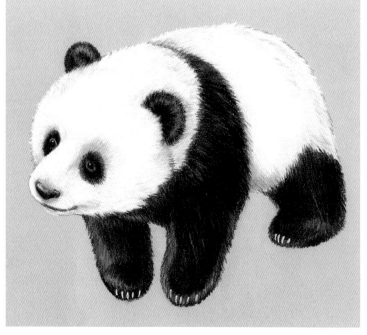

4 Continue building up the fur, using White, Black and French Grey Prismacolor pencils. Use a white gel pen for the highlights of the eyes and the claws.

Bear

Drawing an animal in a slightly humorous pose can add charm and cuteness. For this bear, his rounded tummy and relaxed posture give him a friendly appearance.

MATERIALS

bristol board, graphite pencils, tracing paper, kneaded eraser, PanPastels, eye shadow applicators or PanPastel Sofft Tools, colored pencils, small round brush, Titanium White watercolor

1 Draw your bear on tracing paper and transfer him to a sheet of smooth bristol board.

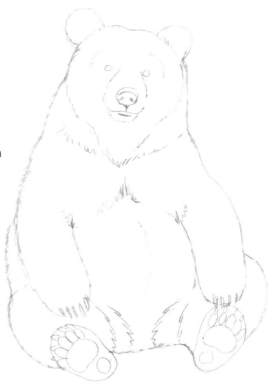

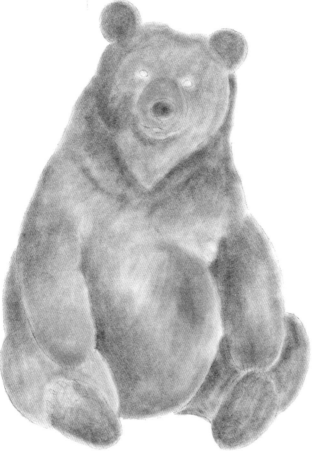

2 I used PanPastels to fill in the base coat of the bear. Apply Raw Umber and Orange Shade with eye shadow applicators or PanPastel Sofft Tools. Place a sheet of tracing paper under your hand to help prevent smearing.

3 Begin shading using Burnt Umber and Burnt Sienna colored pencils and soft scribble strokes. Add details to the eyes, nose and paws with a sharp black colored pencil. The paw pads are shaded with Cold Grey III.

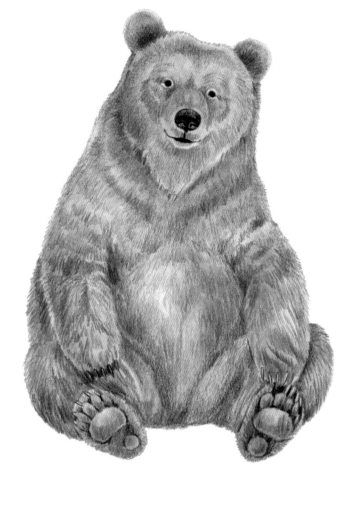

4 Add finer details with Dark Sepia and Black. Sharpen your pencils to a good point. Add highlights with Titanium White watercolor and a small round brush.

Polar Bear

Painting on black paper can really make a light-colored subject stand out. I used Holbein gouache watercolor paints for this polar bear. Using gouache is a little different from traditional watercolor. When painting watercolor in the traditional way, you work from light to dark, and try to leave the white areas as plain paper. With gouache, you paint the lightest areas last. I often add an opaque light layer to my watercolor paintings; I like the solidity it gives.

MATERIALS

black bristol board, tracing paper, white transfer paper, graphite pencils, kneaded eraser, gouache paints, small round brushes

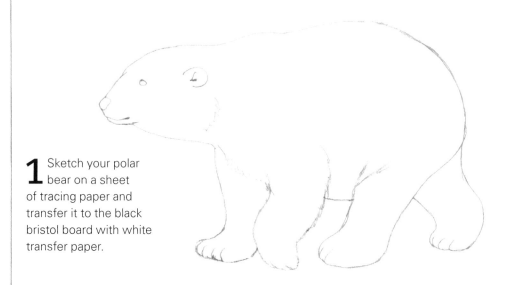

1 Sketch your polar bear on a sheet of tracing paper and transfer it to the black bristol board with white transfer paper.

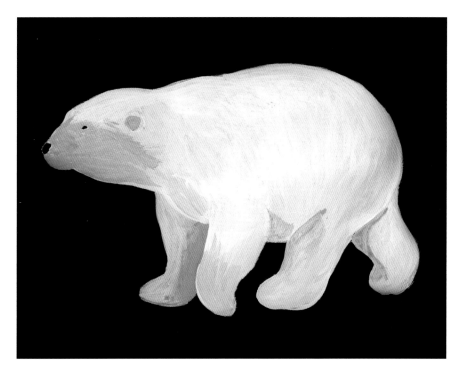

2 Fill in the body of the polar bear with various mixes of Raw Umber and Zinc White opaque watercolors. Use Neutral Grey #2 for the gray areas on the face and in the shading. It may take more than one coat to cover the black paper. Make sure the paint is completely dry between coats.

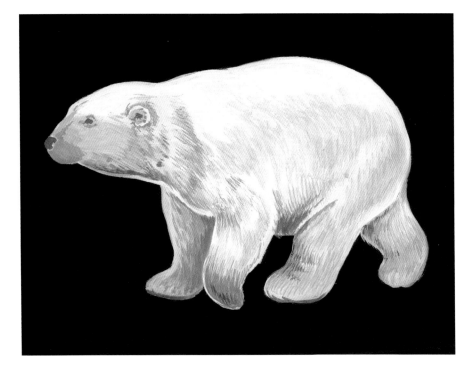

3 Make several mixes of Raw Umber plus Grey #2, and Raw Umber plus Zinc White, then use them to paint the darker areas of fur. The eyes, nose and inside of the ear are painted with a dark mix of Raw Umber and Zinc White.

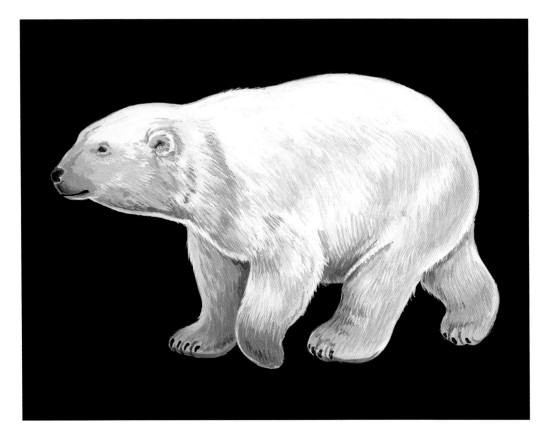

4 Add darks to the eye and nose with black. The claws are painted with Sepia. Finally, paint the lightest fur with Zinc White.

Pond Life Studies

Ponds and wetlands are excellent habitats for a wide variety of animals and plants. When visiting these types of areas, I often take a sketchbook and a camera to take reference photos.

Did you know that in the old days, dragonflies were sometimes called "the devil's darning needle?" Children were told that if they got too close, dragonflies would sew your mouth shut! I wonder why we tell children such silly things.

Herons have long, curved necks and large bills for catching fish. They can be gray, brown, black, white or even green.

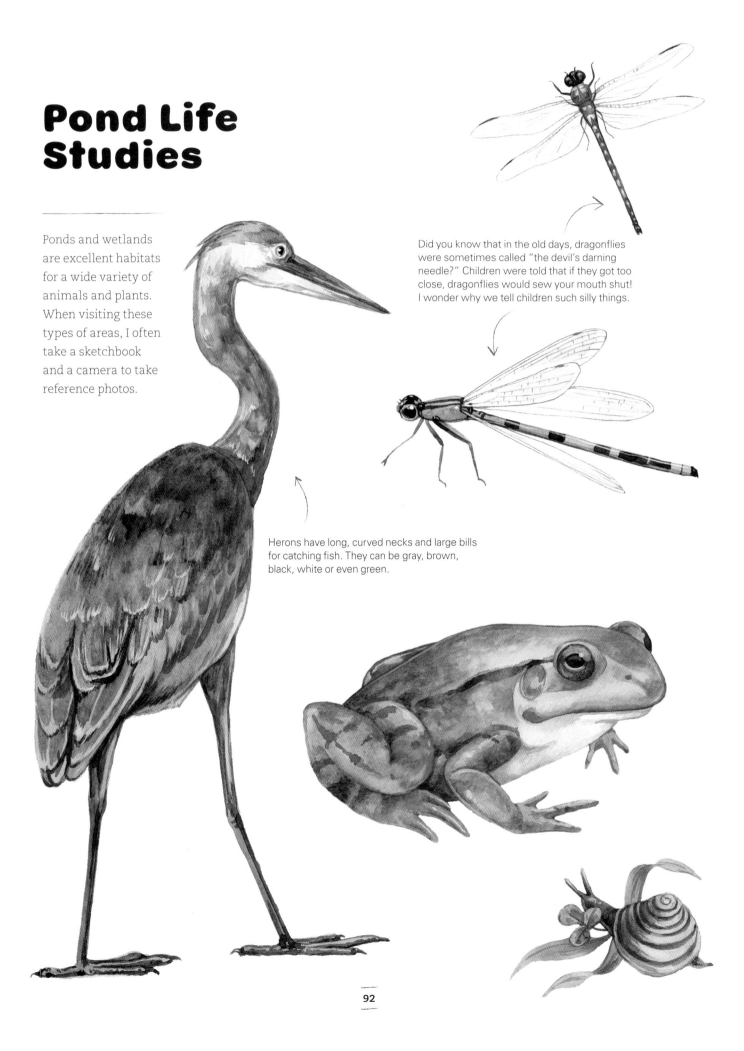

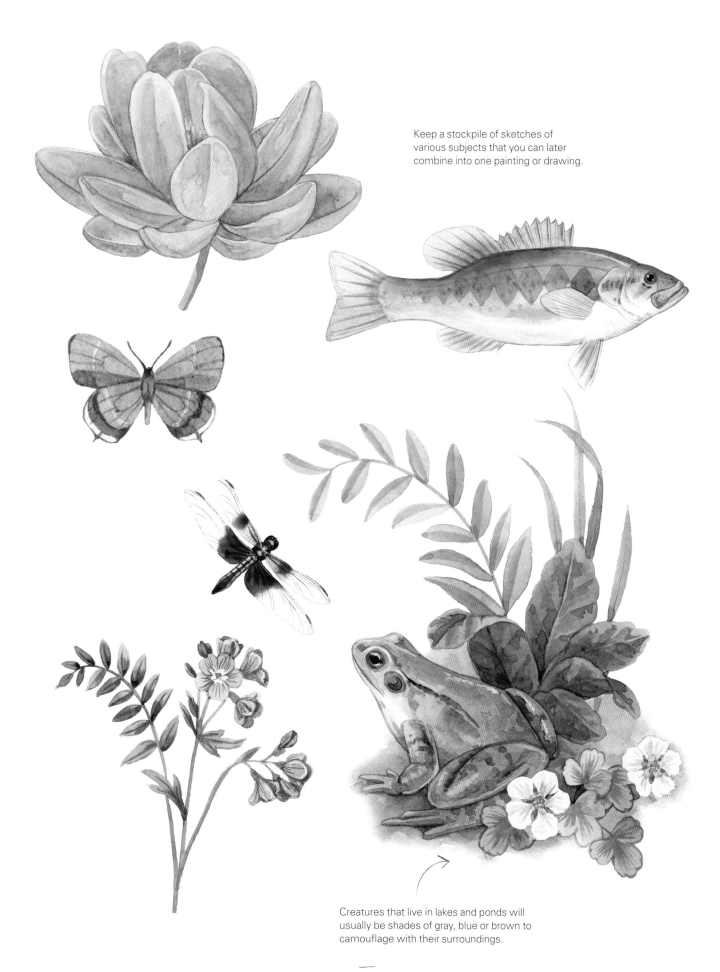

Keep a stockpile of sketches of various subjects that you can later combine into one painting or drawing.

Creatures that live in lakes and ponds will usually be shades of gray, blue or brown to camouflage with their surroundings.

Otter

Otters have so much personality! They are sleek and playful. I chose pastel pencils and Faber-Castell colored pencils for this drawing.

MATERIALS

bristol board, tracing paper, transfer paper, graphite pencils, kneaded eraser, pastel pencils, cotton swab, colored pencils, small round brush, Titanium White watercolor

1 Sketch the otter onto a sheet of tracing paper and transfer him to a sheet of smooth bristol board.

2 With pastel pencils, color around the otter with Teal Blue, and add ground with Dark Brown. Fill in the otter with Light Brown and add a little extra shading with the Dark Brown. Blend with a cotton swab.

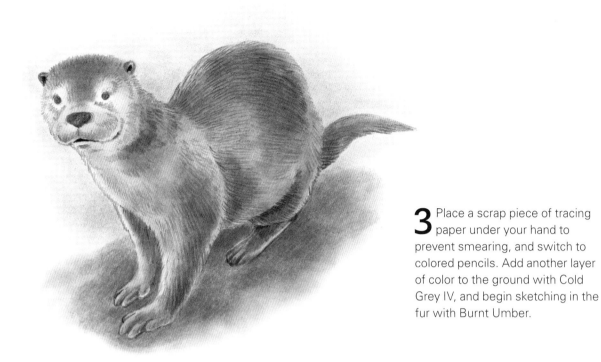

3 Place a scrap piece of tracing paper under your hand to prevent smearing, and switch to colored pencils. Add another layer of color to the ground with Cold Grey IV, and begin sketching in the fur with Burnt Umber.

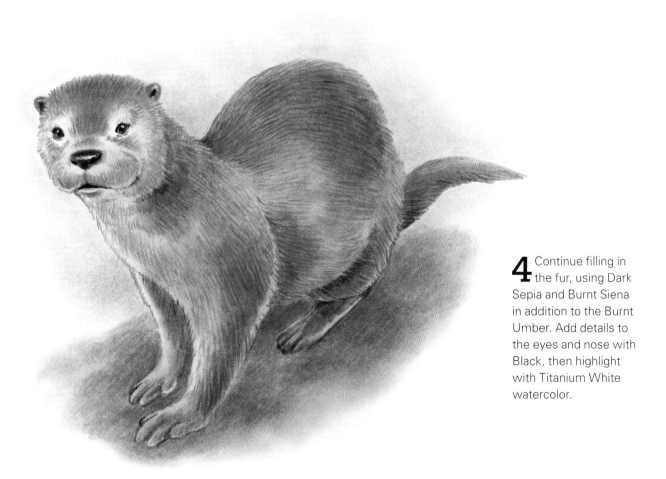

4 Continue filling in the fur, using Dark Sepia and Burnt Siena in addition to the Burnt Umber. Add details to the eyes and nose with Black, then highlight with Titanium White watercolor.

Turtle

Although turtles live in or near the water, they are air-breathing animals who lay their eggs on dry land. Tortoises look similar but are completely land-dwelling. Sea turtles differ because they have flatter shells and flippers instead of feet. I chose watercolor for this demonstration because it would be easier to make him look shiny and a bit wet by using Titanium White highlights.

MATERIALS

bristol board or mixed-media paper, tracing paper, transfer paper, graphite pencils, kneaded eraser, black fine-point pen, watercolor, small round brushes, Titanium White watercolor

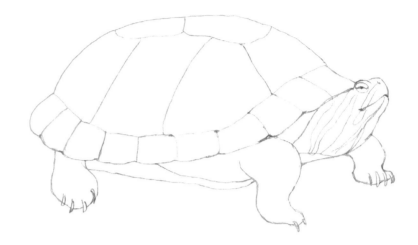

1 Draw the turtle on a piece of tracing paper and transfer it to a sheet of bristol board or mixed-media paper.

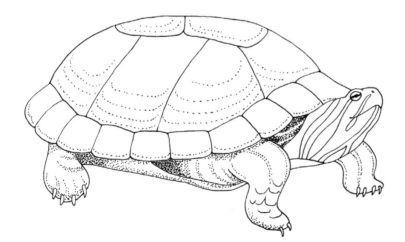

2 Go over the pencil lines with a black fine-point pen. Begin adding shading with stippling. Let the ink dry completely, then erase any remaining pencil lines. A kneaded eraser works well for this.

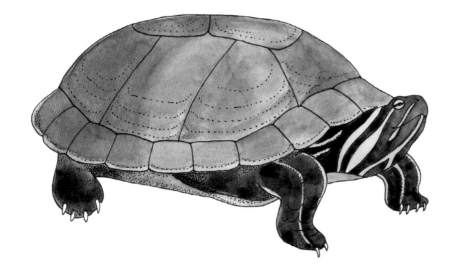

3 Mix together Olive Green and Turquoise Blue watercolors in approximately equal proportions. Dilute and paint the shell, leaving the edge white. Use less water in the mix to paint the legs and head, leaving the stripes white. Let dry thoroughly, then paint the stripes with Cadmium Yellow Hue, and the underside of the shell with Raw Umber. The edges of the shell are Yellow Ochre.

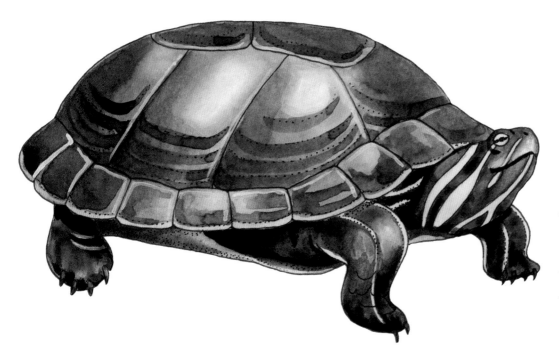

4 Add shading and details with Payne's Gray. Shade the lower shell with Burnt Umber. Add highlights with a small round brush and Titanium White.

Frog

I tried to give this little frog some personality by slightly emphasizing his "smile." I did the base layer with watercolor and then added details with Faber-Castell colored pencils.

MATERIALS

bristol board or mixed-media paper, graphite pencils, kneaded eraser, watercolor, round brushes, colored pencils, blender pen, waterproof ink pen, Titanium White watercolor

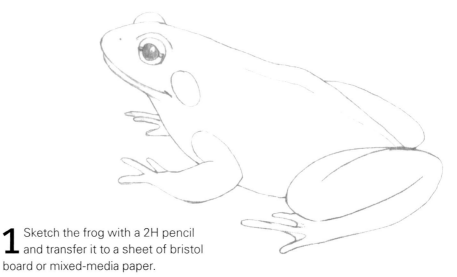

1 Sketch the frog with a 2H pencil and transfer it to a sheet of bristol board or mixed-media paper.

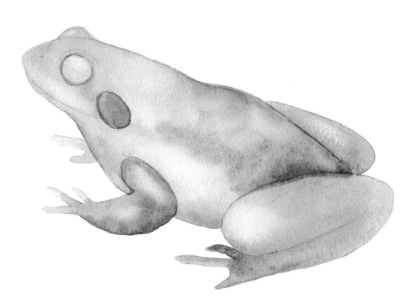

2 Wet the frog's head and body with clean water on your brush. While the paper is still wet, lay in some washes of Olive Green, Yellow Ochre and Raw Umber, letting the colors blend together for a mottled appearance. Repeat with the legs, wetting each one and laying in the paint before the paper dries. You can lift out some lighter areas by blotting the wet paint with a dry tissue if you wish. The eye is Yellow Ochre.

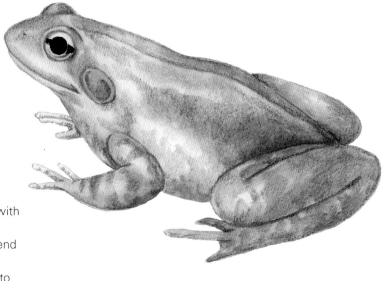

3 Begin building up the colors with colored pencils. I used Olive Green, Bistre and May Green. Blend with a blender pen. With a black Pigma Micron pen, add the pupil to the eye.

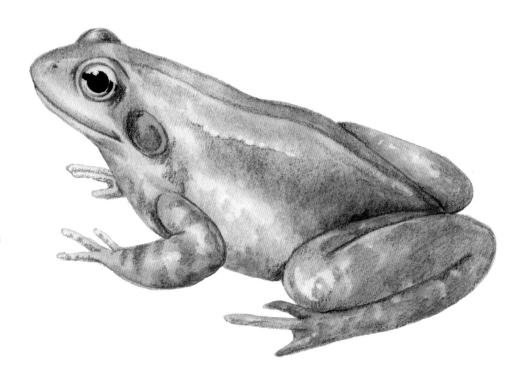

4 Add the final dark details with a Burnt Umber pencil and the highlights with Titanium White watercolor and a small round brush.

Insect Studies

You may not think of insects as super cute, but I do like to draw them. It is good to add some to your drawings of other adorable creatures because they can add more life and naturalism to a scene.

Insects have three body parts: the head, thorax and abdomen. They have six legs, which are attached to the thorax.

Adding motion helps your art look less stiff and posed.

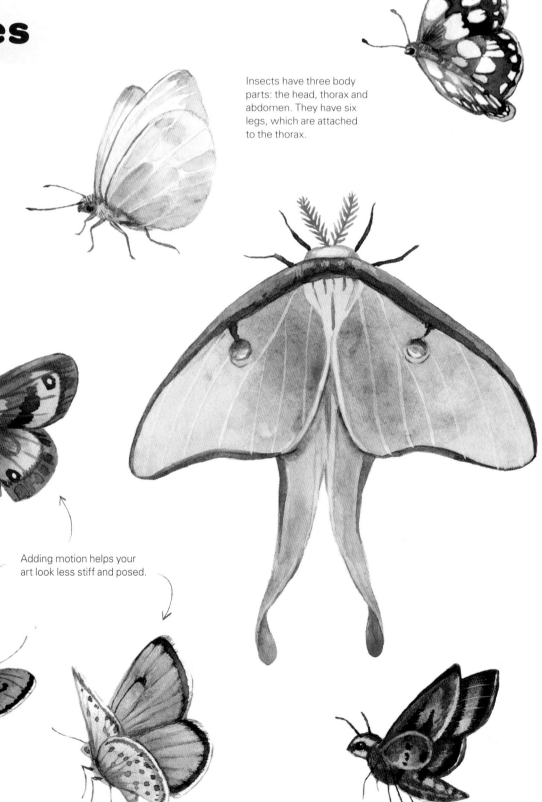

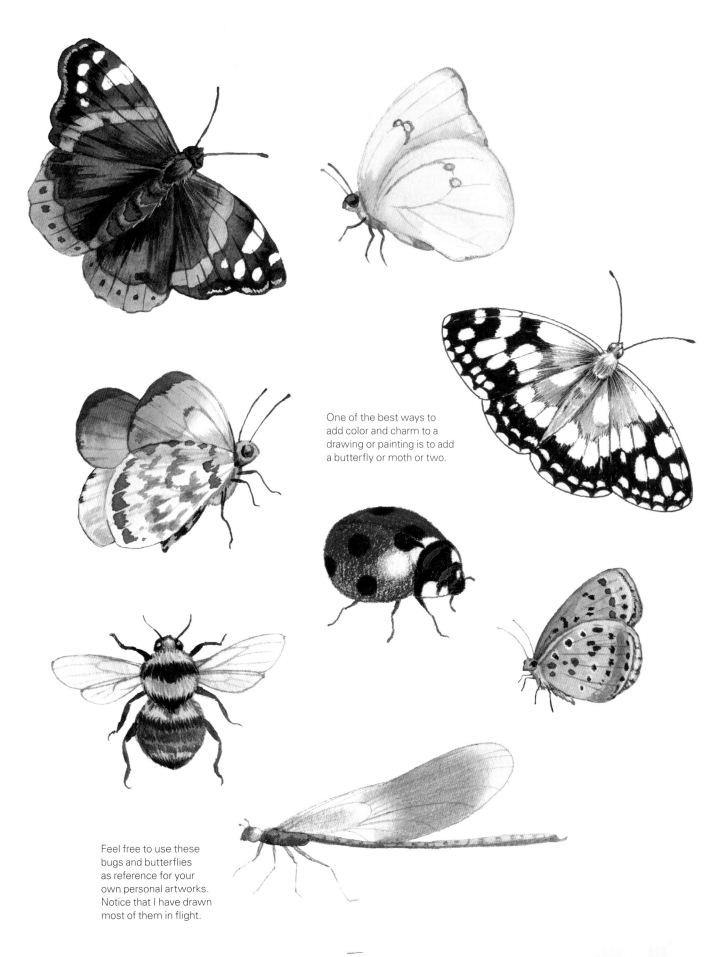

One of the best ways to add color and charm to a drawing or painting is to add a butterfly or moth or two.

Feel free to use these bugs and butterflies as reference for your own personal artworks. Notice that I have drawn most of them in flight.

Butterflies

Drawing and painting butterflies is difficult because it's hard to capture their fragility. I find it helps if I think of their wings as sheets of thin paper. This helps me get the angle right when I am drawing them in flight.

MATERIALS

bristol board or mixed-media paper, tracing paper, transfer paper, graphite pencils, kneaded eraser, watercolors, round brushes, Titanium White watercolor

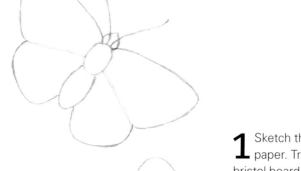

1 Sketch the butterflies onto tracing paper. Transfer to a sheet of bristol board or mixed-media paper.

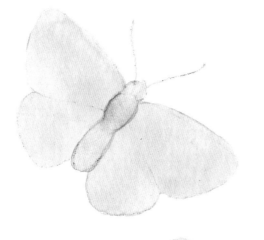

2 Paint the wings with Gamboge Yellow watercolor and a round brush. Use Yellow Ochre for the outer wing on the lower butterfly. The bodies are a thin wash of diluted Payne's Gray.

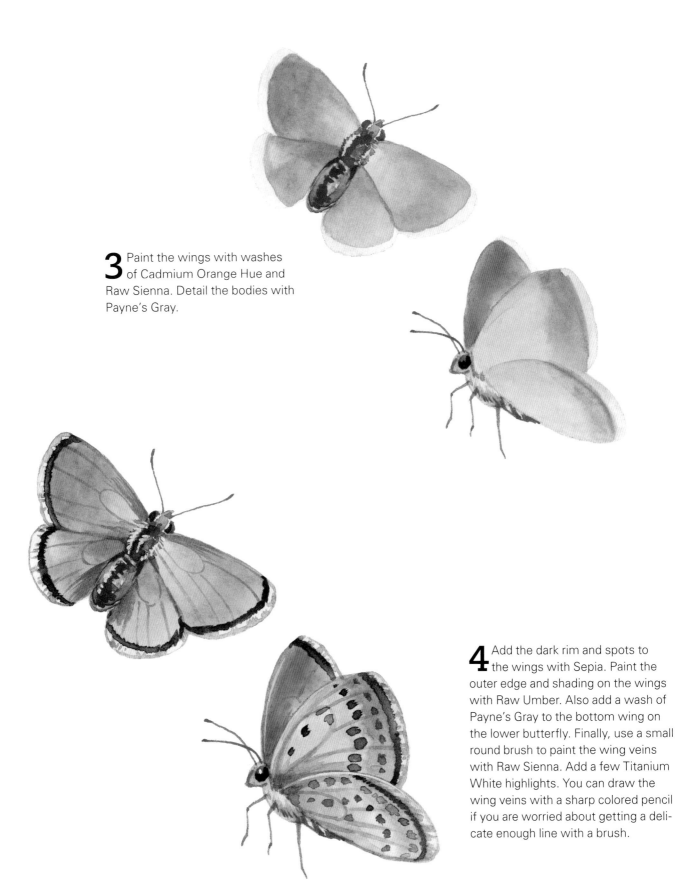

3 Paint the wings with washes of Cadmium Orange Hue and Raw Sienna. Detail the bodies with Payne's Gray.

4 Add the dark rim and spots to the wings with Sepia. Paint the outer edge and shading on the wings with Raw Umber. Also add a wash of Payne's Gray to the bottom wing on the lower butterfly. Finally, use a small round brush to paint the wing veins with Raw Sienna. Add a few Titanium White highlights. You can draw the wing veins with a sharp colored pencil if you are worried about getting a delicate enough line with a brush.

Flower Studies

I like keeping paintings of flowers in my sketchbook to use as a reference for future paintings. Feel free to practice by copying the flowers I have drawn here.

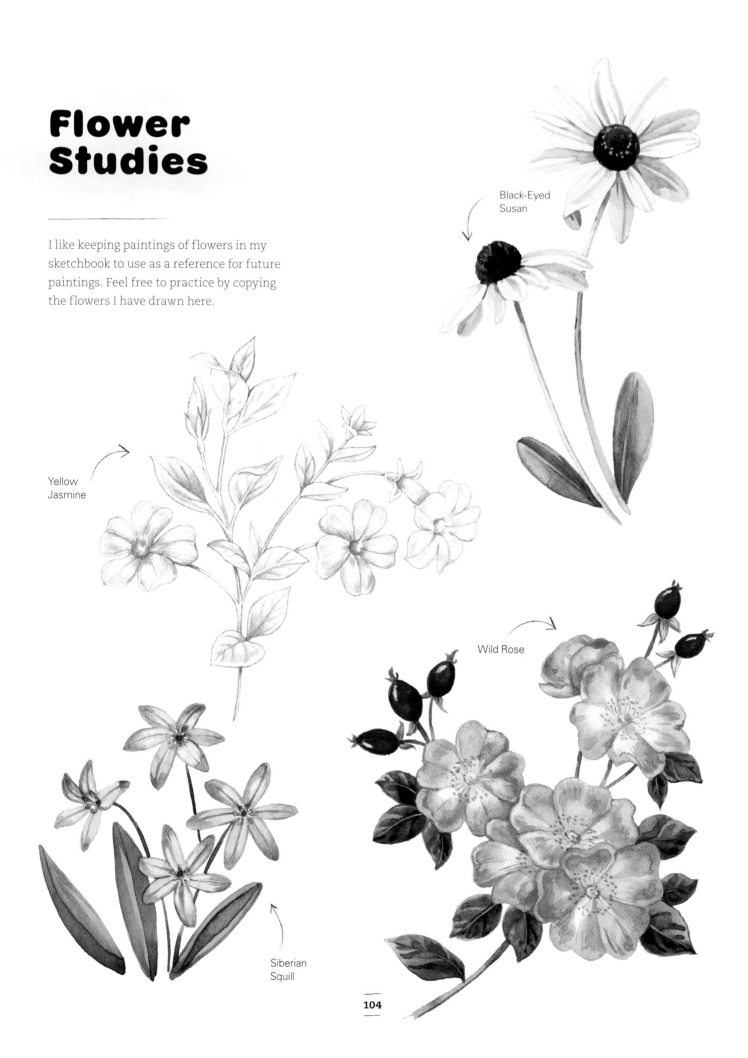

Black-Eyed Susan

Yellow Jasmine

Wild Rose

Siberian Squill

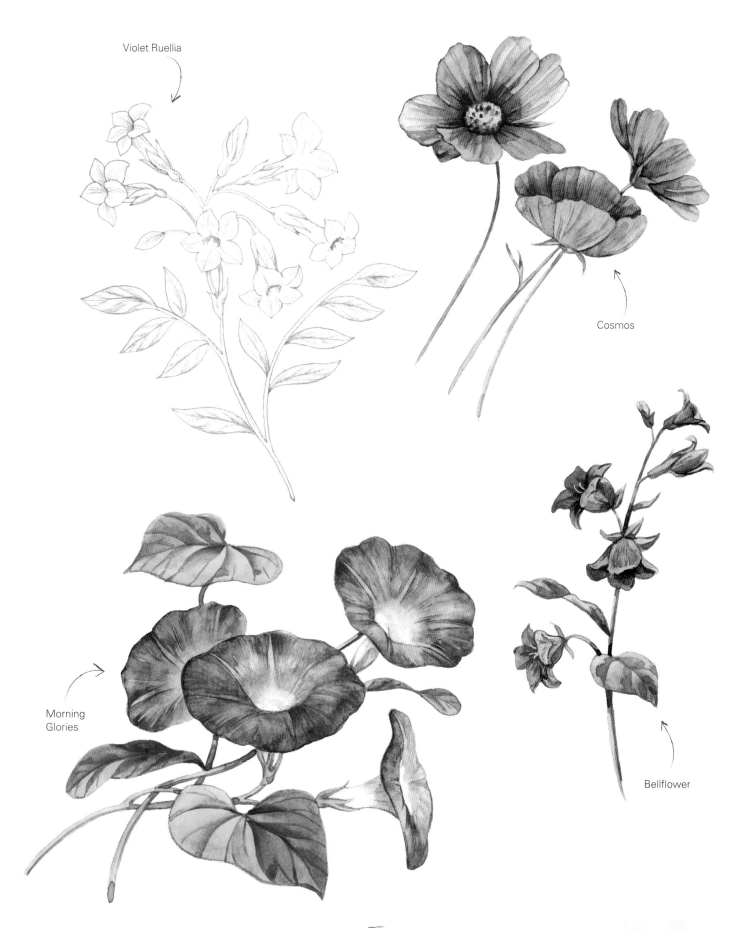

Violet Ruellia

Cosmos

Morning
Glories

Bellflower

Putting It All Together in a Scene

Throughout this book I have shown you examples from my sketchbooks of flora and fauna. I keep photos and sketches of all my favorite subjects so that I can use them in future paintings. Here are some tips on how to build a painting comprised of many different elements, and how to put them together to create a pleasing and natural composition.

Try to make sure that your elements all work together. For example, make sure the flowers are all ones that would be blooming at the same time, or if you are painting a winter scene, make sure the animals or birds have their winter coloration.

To make a composition of multiple subjects in a scene, try sketching the elements onto tracing paper or vellum. Then cut them out and move them around until you have a layout that you like.

You can also arrange your composition with photographs. Photocopy the images, then cut them out and move them around. If you have photo-editing software such as Photoshop Elements, you can do this on your computer.

Index

About the Author

Born in England and raised in the United States, Jane Maday has been a professional artist since she was fourteen years old. At sixteen, she was hired by the University of Florida as a scientific illustrator. After graduating from the Ringling College of Art and Design, Jane was recruited by Hallmark Cards, Inc., as a greeting card illustrator. She left the corporate world after her children were born and now licenses her work for products such as cards, garden flags, jigsaw puzzles, home décor and more. Jane is the author of many magazine articles and the best-selling art instruction book, *Draw Baby Animals*, as well as *Color Super Cute Animals*, *Adorable Animals Grayscale Coloring Book* and *Super Cute World: A Coloring & Creativity Book*. She lives in scenic Colorado with her husband and children. For more, visit janemaday.com.

Dedication

This book is for all the new friends I have made out in the art world. I hope that you all love the book!

Acknowledgments

Big thanks to all the gang at F+W Media, especially Mona Clough and Sarah Laichas, for helping me put this book together. Thanks also to Sharon Eide, Katie Horrocks and Barbara Hymer for help with reference photographs.

NORTH LIGHT BOOKS

An imprint of Penguin Random House LLC
penguinrandomhouse.com

ISBN 978-1-4403-5332-1

Printed in China

10 9 8 7 6 5 4 3

Edited by Sarah Laichas
Production edited by Jennifer Zellner
Designed by Charlene Tiedemann
Cover designed by Clare Finney

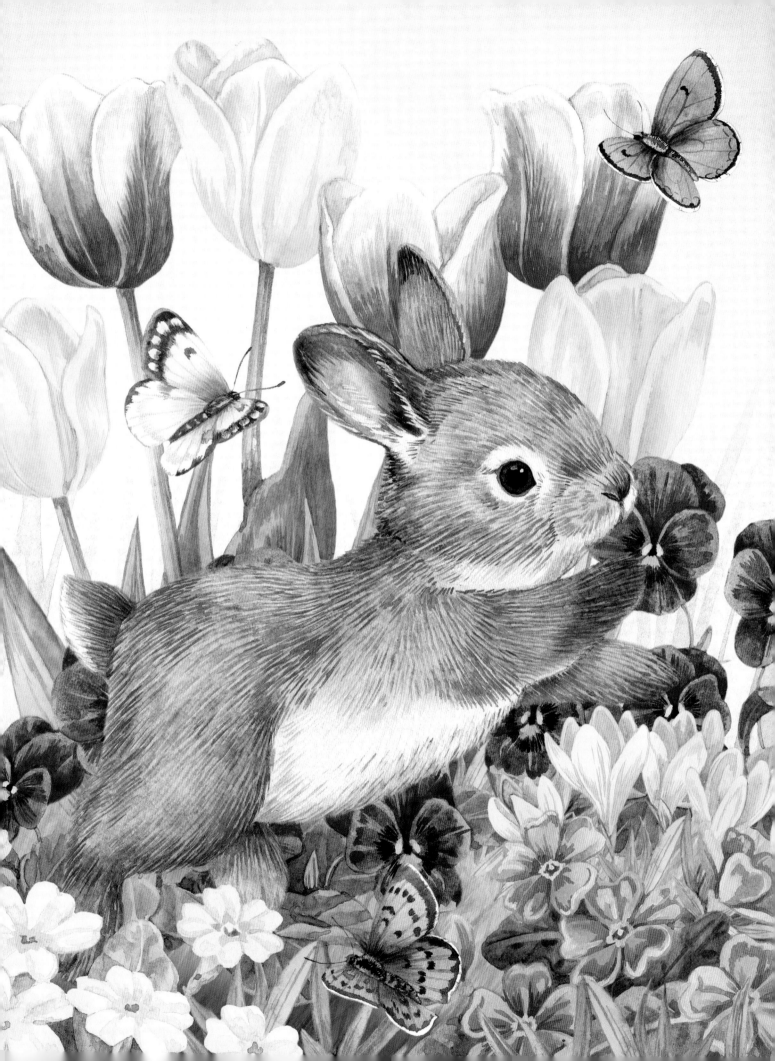

Also available from
JANE MADAY

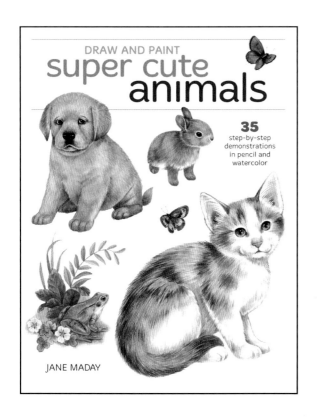